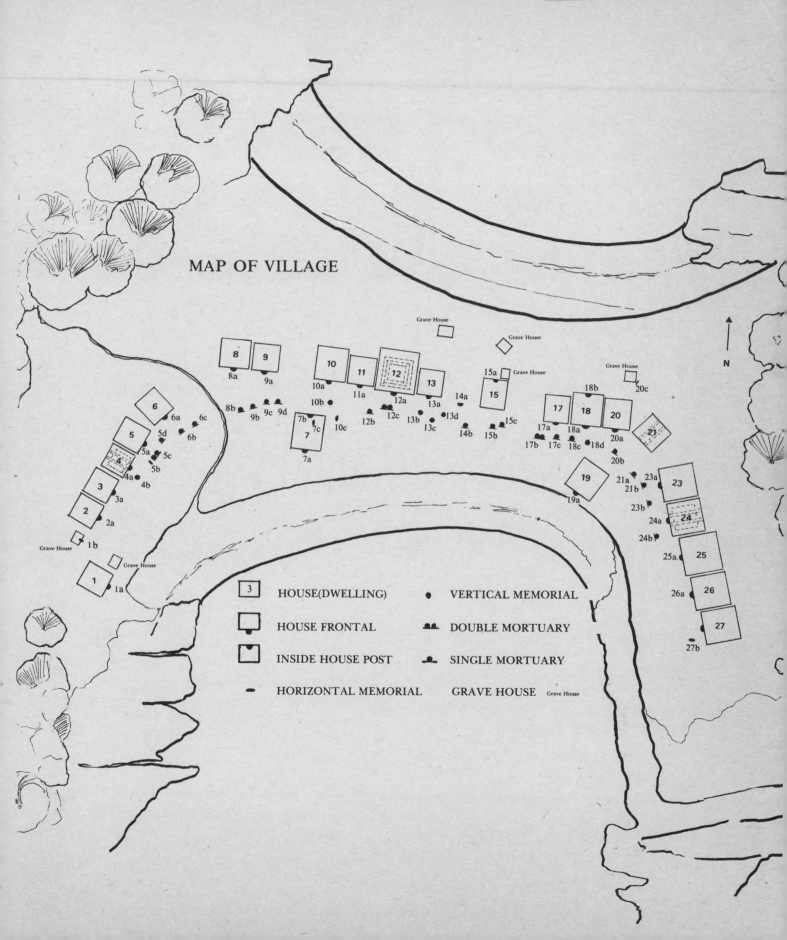

MAP OF VILLAGE

N

HOUSE(DWELLING) VERTICAL MEMORIAL

HOUSE FRONTAL DOUBLE MORTUARY

INSIDE HOUSE POST SINGLE MORTUARY

HORIZONTAL MEMORIAL GRAVE HOUSE Grave House

the totem poles of SKEDANS

Written and Illustrated by
JOHN AND CAROLYN SMYLY

University of Washington Press

Seattle

LIBRARY OF CONGRESS CATALOG
CARD NUMBER 73-84988

ISBN (cloth) 0-295-95417-5
ISBN (paper) 0-295-95418-3

University of Washington Press edition first published 1975

This edition is not for sale in Canada. Exclusive rights for this territory reside with Hancock House Publishers, 3215 Island View Road, Saanichton, B.C., Canada.

Title of original edition: Those Born at Koona: The Totem Poles of the Haida Village Skedans, Queen Charlotte Islands.

COVER PHOTO COURTESY OF
BRITISH COLUMBIA DEPT. OF TRAVEL.
HISTORICAL PHOTOGRAPHS COURTESY OF:
ETHNOLOGY DIVISION, PROVINCIAL MUSEUM,
VICTORIA, B.C., CANADA.
PUBLIC ARCHIVES OF CANADA, OTTAWA

PRINTED IN CANADA BY:

FLEMING-REVIEW PRINTING LTD.
921 YATES STREET
VICTORIA, BRITISH COLUMBIA

DEDICATION

TO RUTH GREGG CASE,
who encouraged us.

CONTENTS

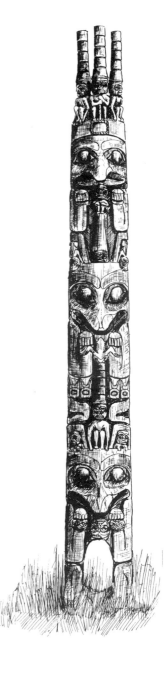

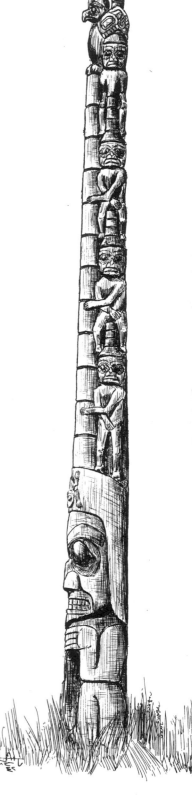

NOTE ON ILLUSTRATIONS

There has been no official plan as yet to under-
take the reconstruction of an entire Indian
village, such as has been done for pioneer settle-
ments all across Canada. But in 1956 I was com-
missioned by the Provincial Museum in Vic-
toria, British Columbia, to produce three Haida
houses and representative group of poles — in
miniature. Using a scale of five-sixteenths of an
inch to the foot, I finished the models and they
were included in the anthropological display in
the basement of the old Museum in Victoria.

When a new museum was planned, and I joined
the staff in 1965, it became my task to complete
a model of an entire Haida village. Skedans was
chosen as a prototype because of the variety of
its poles and the beauty of its natural setting.
Working almost entirely from the Dawson
photographs of 1878, I sketched fifty-four of the
fifty-six poles. (Two poles were almost com-
pletely hidden). I used a magnifying glass, and
finally a jeweller's eyepiece to recover as many of
the details as possible. The sketches were then
translated into miniature carvings.

Photographs of these carvings have been used to
illustrate many of the poles in this book where
original photos were not available. The model
village completed this year will soon be on
display.

JOHN SMYLY WITH MODEL POLE

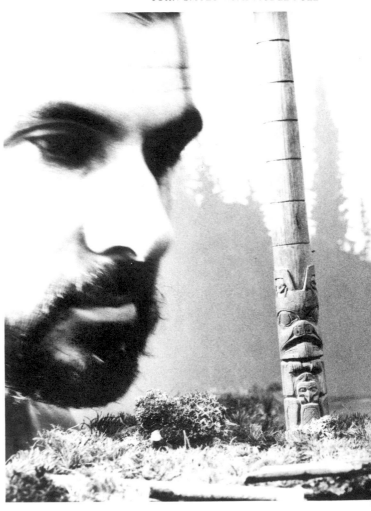

ACKNOWLEDGEMENTS

Our greatest personal debt is to the staff of the Provincial Museum in Victoria, British Columbia. The late Dr. Clifford Carl, Director for many years of the Provincial Museum, originally commissioned me to build a model of a Haida village, and it was he who encouraged my interest in the Haida totem pole. Through Dr. Carl I made the acquaintance of Wilson Duff, then the anthropologist at the Museum, who included me as an "extra" on the salvage trip to Anthony Island in 1957 when brief visits were made to Skedans. Wilson spent many hours of his time instructing me in the necessary background knowledge for the model, and he and Michael Kew (also on the Museum staff at that time), suggested written references and answered my endless questions.

To Peter Macnair and Alan Hoover, presently of the Anthropology Division of the Provincial Museum, who have read the manuscript and generously given of their time and expertise, we extend our thanks. We should like to acknowledge as well, Bill Holm, Curator of Northwest Coast Art at the University of Washington, for his detailed and lucid explanation of the significant details in the study of the art form.

I should like to express my gratitude to my wife, Carolyn, who convinced me I should try to write a book about the village I had been studying for so long, and who offered to tackle my notes, research the printed works, and type the results. I am also grateful to her for agreeing to share the blame. Readers will soon discover, as we did, how very little contemporary or first-hand material there is regarding individual totem figures. We have done our best with what written sources are available and have questioned anyone we thought might have more information, but as for our interpretations and our assumptions, if they prove to be erroneous, the fault is entirely our own.

John Smyly
Victoria, 1973.

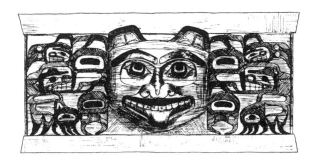

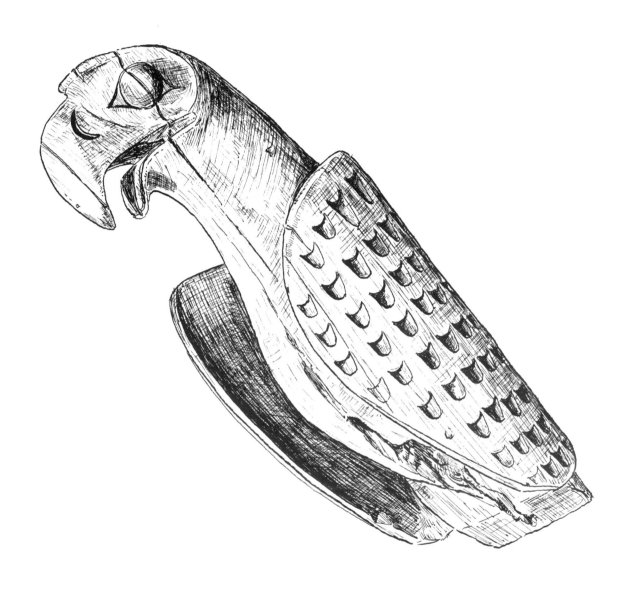

ONE OF THOSE BORN AT KOONA

PREFACE

The eagle was one of those born at Koona.

He is a totem. Long ago when the village of Koona was the winter home of five hundred Haida Indians, an eagle was needed to mark a small gravehouse at the western end of the village. Stacked inside the gravehouse were many carved and painted boxes each containing the bones of an Eagle person from Koona. Eagle chiefs had their own splendid tombs at the top of mortuary poles but the ordinary family members were laid to rest in the little grave-houses. An eagle was needed to show that these people had belonged to the Eagle division of the Haida people.

An artist, whose name is unknown to us, was chosen to carve the eagle. He cut a block of red cedar more than seven feet in length and almost three feet in diameter and using an axe and a long-handled adze roughed out the shape of the eagle's body and wings. A chisel, the smaller hand adze and a curved knife were used to smooth the surface and carve the deep lines of the eyes, the beak and the feathers. Then the wood was painted: white head and neck, black body and wings like the great Bald Eagles which float on the air currents above the Queen Charlotte Islands. The eyes of the eagle were particularly important. They were made round and bulging, fixed open in a permanent stare. They were outlined in crimson.

The eagle was raised to the roof of the grave-house where a stout wooden post was driven upwards into his body to hold him to his perch. Over many years the weather buffed and polished him to silver grey.

For a long time the eagle overlooked the village as the early morning sun rose over the headland separating the U-shaped bay of Koona from the waters of Hecate Strait. For years the canoes came and went despite the kelp beds that tangled the passage and the changing seasons that crumpled or smoothed the water's surface. The eagle stood, unsleeping sentry over all of it and over the long row of Haida houses which swept away in an arc to his left until they rounded the end of the bay and faced him again over the water.

Then Koona was abandoned and the canoes came only once in awhile. The twenty-seven dwellings collapsed. The gravehouse upon which the eagle had perched, decayed, and the grave-boxes within, containing the bones of the Eagle family, melted into the soil.

The forest grew back.

By 1971, a lumber camp had made its head-quarters on the peninsula and a logging road was bulldozed straight through the village and down onto the beach. The long quiet was broken by voices, the growl of heavy motors, the splash of logs into the bay. After eighty years, men came again to Koona.

But those born at Koona had gone.

The eagle now stands incongruously upon his tail in a storeroom of the Provincial Museum, Victoria. To some he is merely a wooden bird, rather crudely carved and misproportioned. To others, he is awesome, magnificent. Artists admire him for the deep strong carving, the power and simplicity of the design. Anthro-

pologists admire him for the complex social and religious organization which he symbolizes. Collectors and dealers admire him, in part at least, for his enormous value on the art market. Others admire him without the least knowing why. Such is the power of the Haida artist.

The difference between the points of view lies in what the observer happens to know about totems. The difference, one might say, lies in knowing something about a village like Koona, the people who lived there, the reasons for carving figures like the eagle, and the place of those carvings today.

One would think that in a province unique for its heritage of poles there would be a substantial number of books to be found on the subject. A glance at the shelves of any library shows this to be far from the case. The Northwest Coast Indian of the 19th century has been dealt with, his religion, ceremonials and complicated social organization expounded. Much remains to be written, preferably by the people themselves, of the Indians of the 20th century. Their traditions have preserved their sense of identity and they attempt today to find a place in society which is a home to the best of the old and the new.

In recent years, Northwest Coast Indian art has experienced a revival of popular interest. The Haida themselves, such as Bill Reid and Bob Davidson have turned back to museum collections to re-learn the subtleties of the traditional designs. It is now possible to find books general-izing about 19th century Haida art, its elements, its careful and controlled formlines, its use of colour and so forth. But only one author, Marius Barbeau, has ever attempted to catalogue or to concentrate exclusively upon the totem poles of British Columbia and his record is far from complete. Koona, for example, is reduced to a single page of text and a few photographs. For fifteen years or more, we have waited for someone else, anyone else, with training or with firsthand knowledge of totem poles to write a book describing a Haida village and its monuments. No one has.

Here then is our contribution towards a much-neglected subject. This is not a book about Indians. It is not a book about Haida art. It is a book about the totem poles of Koona, their crest figures and their meaning. For the Haida people themselves, many of whom may never have seen the poles illustrated here, and for all persons who are amazed, puzzled and intrigued by these massive monuments, we have attempted to re-create as best we can the totem poles of the village of Koona. Today this village on Louise Island on the southeast side of the Queen Charlotte Islands, is called Skedans.

We hope that the errors and omissions we may have made will cause some Haida person to say, "I can do better than that," and set about the task as it should be done, written and illustrated by the descendants of those who once lived at Koona.

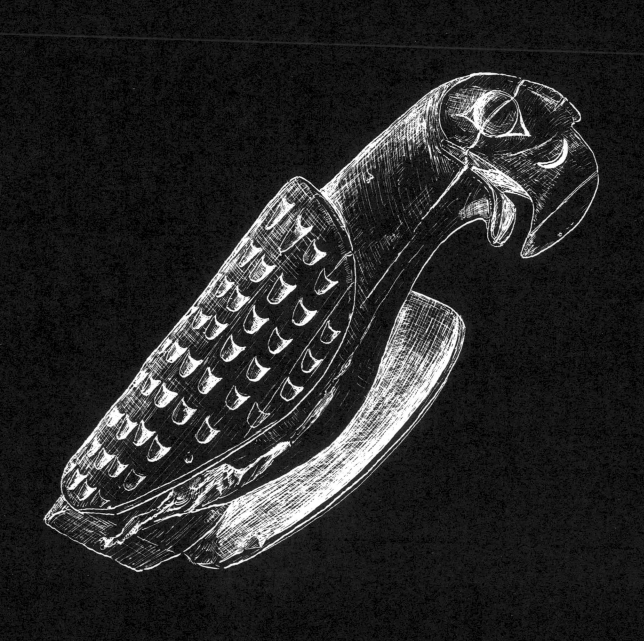

CHAPTER I
THE VILLAGE

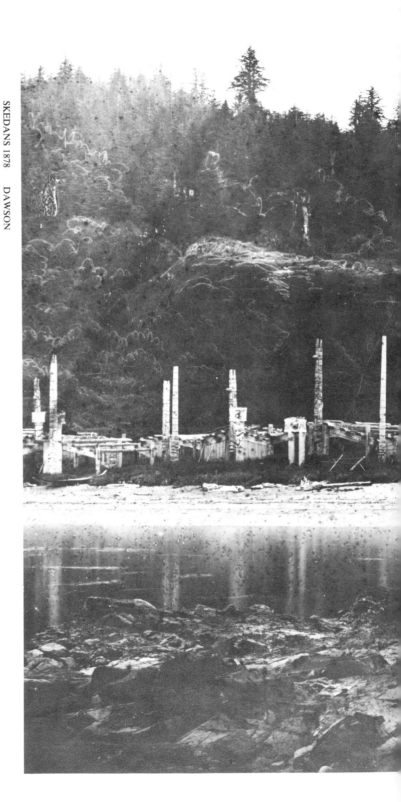

SKEDANS 1878 DAWSON

The sky was solid and curved down to the earth like a stone bowl overturned. Hung from the sky but moving in currents of their own were the stars, the sun and the moon which lit the expanse beneath the dome of the sky. The earth was flat, like an immense platter, and filled to the brim with an ocean which heaved and rolled, whose tides sucked and eddied about submerged reefs.

Two islands floated on the surface of the sea, the Queen Charlottes in the west, and another (the mainland) in the east. Deep down in the cold grey waters, on a copper box far beneath the Queen Charlotte Islands, stood a Haida spirit, Sacred-One-Standing-and-Moving. It was he who held fast to the Haida lands, anchoring them against the relentless pressures of the sea.

This Haida story of origins[1] was preserved for centuries as one small part of a vast oral tradition. The Haida had no written symbols to record their history, literature, music, philosophy, medicine, crafts or religion. Instead, fact was woven into the fabric of legend and song, taught by rote to the children until they could repeat every syllable and then carried by ear and by tongue through every generation.

These legends, together with archaeological

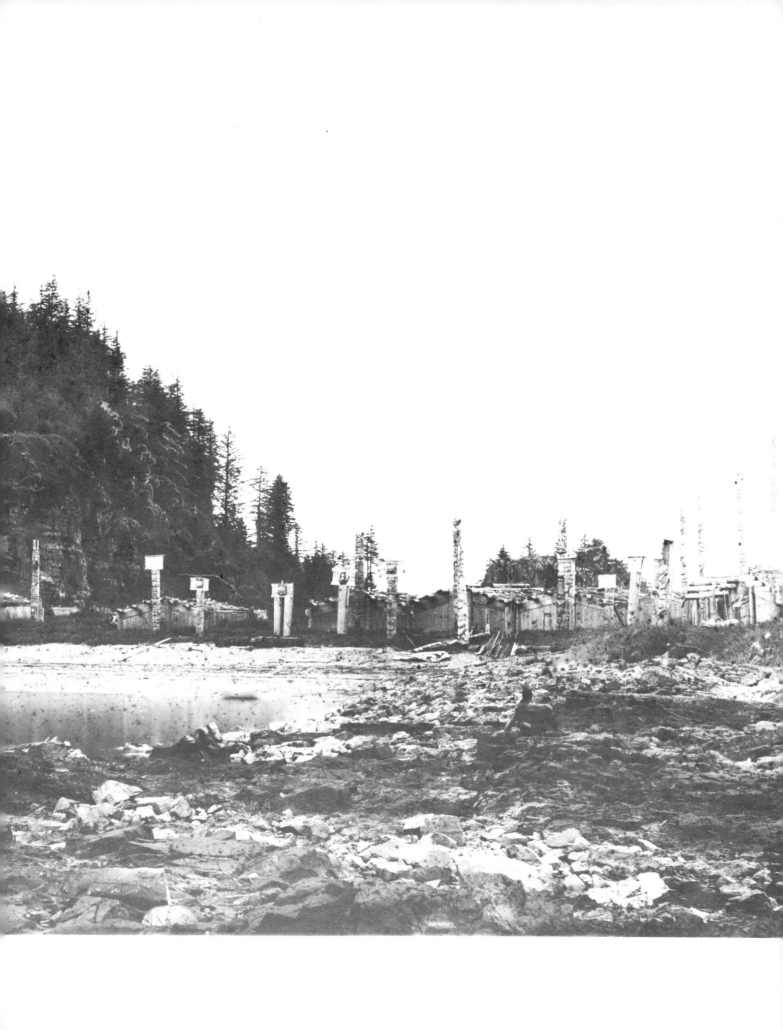

INDIAN MIDDEN

SPRUCE FOREST

gathered, or a sun-dappled stream where fish could be netted, trapped or speared. The women sought bird eggs, and picked berries, roots, and bark. The men hunted animals and birds, fished for halibut and cod in the sea, and harpooned the sea-mammals for their meat, oil and furs. The harvest of the summer was preserved for the winter; dried, smoked or packed in oil.

Then when the winds rose in a different quarter and the autumn rains came, the Haida returned to the greater protection of their winter villages. They drew together into the permanent settlements where fifty-foot wooden community houses had been built. Once beneath shelter, the feasts and entertainments began. High-born families sent invitations to the high-born of other villages. Guests came and were honoured with speeches and many gifts. As the great fires

evidence sifted from the shell middens of long-occupied sites, the journals kept by explorers, notations made by anthropologists and the few startling photographs left by pioneer photographers, are all that remain for us as working materials for a written history. From these sources the broad outlines of a story may be traced. But many of the finer details have been sponged out until a complete understanding and appreciation of the old ways is no longer possible.

We do not know exactly where the coastal Indians came from originally, nor when, nor why they left their homeland. Almost certainly arriving from Asia, they seem to have crossed by way of the Bering land bridge in a series of gradual, almost imperceptible migrations in search of food. Those who settled eventually upon the Queen Charlotte Islands and the southern half of Prince of Wales Island, now part of Alaska, are known as the Haida.

Once they had established themselves, they fell into the rhythm of the seasons, migrating like birds in spring and autumn. Summer found them scattered among a hundred or more temporary camps where food could be found in variety and abundance. Each family group claimed a certain beach were shellfish could be

16

leapt from the central hearth and sparks rose to the smoke-hole in the roof to be whisked into the wet night, the costumed dancers moved carefully through the intricate steps they had been at such pains to learn. Family histories were retold, lovingly, without haste. Honour was paid to the dead and to the living far into the night, week after week.

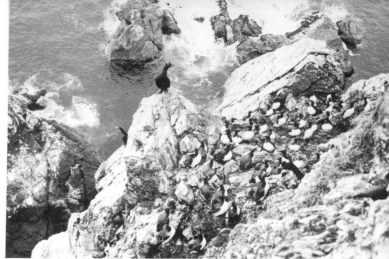

COMMON MURRES

ANCIENT MURRELETS NESTING UNDER SPRUCE TREES WERE DUG OUT FOR FOOD

The days were spent making and mending and it was here that the Haida, like all the coastal tribes, demonstrated a particular genius. Wood was the common denominator for all things manufactured. Every part of a tree might be used; roots, inner bark, twigs and trunk. The house planks and posts had been split from logs well over a hundred feet in length. Canoes were hollowed from logs, then steamed and spread to a distinctive and time-tested design. The storage boxes holding the winter's supply of food were planks which had been scored deeply at the corners, then steamed, bent into shape and sewn together with fitted bottoms and lids. Tool handles were shaped from forked branches or roots. The inset cutting blades were stone fragments, animal teeth or shells. Clothing, baskets, mats and rain hats were woven from spruce roots or the supple inner bark of the cedar.

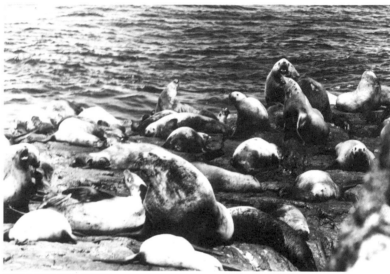

STELLAR'S SEA LIONS

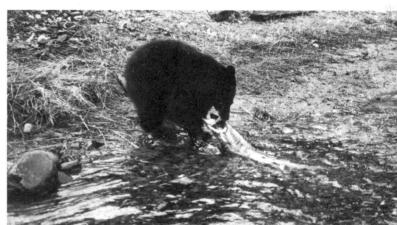

BLACK BEAR WITH SPAWNING SALMON

Working continually with wood — cutting it, splitting it, steaming it, shaping it, it was very natural that at some time in history the Indians should begin to decorate it as well. Designs were incised and painted when a flat surface like a box or a house front were to be ornamented. But tools and utensils, masks, rattles, bowls and spoons gave an opportunity for full sculpture.

They carved in the likeness of the forms they saw around them: the beaver, wolf and bear, the whale and seal, the birds of the air, the natural and the supernatural phenomena which they had seen or had heard about from other tribes.

Season followed season and the Haida canoes followed after. Then, in the last half of the

eighteenth century, European traders appeared in their sailing vessels like great white birds rising out of the sea. Metal bladed tools passed quickly in trade, and soon became plentiful. The wood carvings, while retaining their traditional forms, could be made much more quickly and increased in size. The Spanish and English explorers of the early 19th century described the villages they saw along the coast. "Grotesque" was a word frequently employed to describe the house frontal paintings portraying family crests and the upright posts set in the ground which served as the tombs of the chiefs. Unable to communicate with the Indians except by sign language, the visitors did not know what to make of the monuments, calling them "idols", which they were not, and only gradually learning of their real significance.

Koona was not mentioned by name in these very early accounts. It had been a winter village, sheltered within a bay on the north-eastern coast of Louise Island, a bay almost unnaturally perfect in shape, like a basket turned to the south to trap the sun. Fresh water in the form of a creek fed into the bay at the western corner. The village had had twenty-seven dwellings and fifty-six carved monuments at the height of its fortunes. In the 1830's when John Work of the Hudson's Bay Company included it in a list of trading sites, it had 471 inhabitants, including many children.[2]

Work called the village "Skee-dans" which was not its true name but a corruption of the name of its chief, Gidansta. The European tongue has always found Indian names almost impossible to pronounce and so Gidansta's village of Q'ona

SKEDANS PROVINCIAL MUSEUM PHOTO

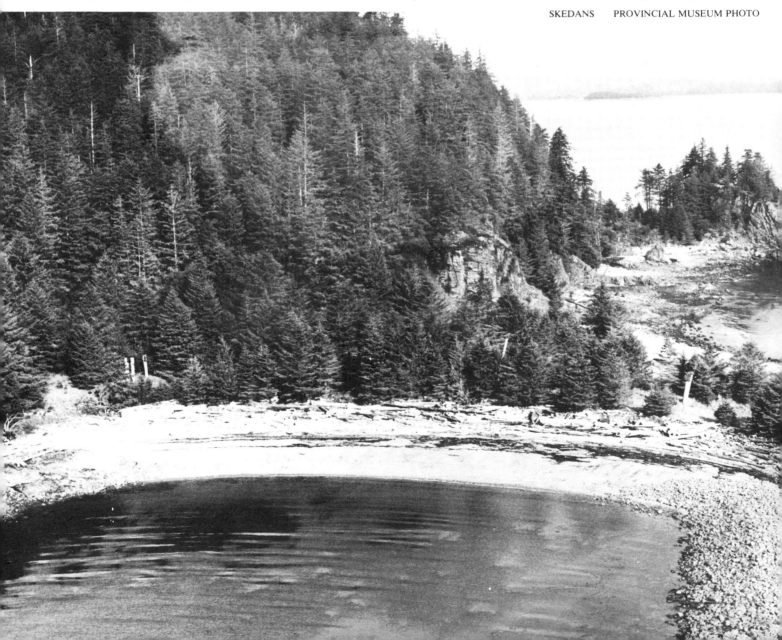

(or Koona) became known as Skedans and is called that to this day.

A descendant chief of Skedans was asked many years later to list the houses and families of old Koona. The list thus preserved[3] is particularly valuable. It is the only contemporary written record there is of the composition of the village. It was given by a man who had lived at Koona, known the families there, and could extend his memory over at least thirty years of its existence. The houses and families of Koona were a reflection of Haida society as a whole. Both major social groups or phratries were represented, the Ravens and the Eagles. The Ravens were said to have descended originally from a mythical ancestress called "Foam Woman." The Eagles were supposed to have sprung from the ancestress Djila qons (or "Great Mountain"). Each

mythical "mother" had had several daughters who, in turn, had given birth to individual clans, each named after the place where the clan made its permanent home: Those-born-at-Koona, Those-born-at-Qagials, Those-born-at-Rose-Spit, and so forth.

Originally a village in the Queen Charlottes would have been entirely Ravens or entirely Eagles, but wars, competition and intermarriage had resulted in most villages being a mixture of Raven and Eagle families. There was often friction between neighbouring groups of opposite phratry, despite (or perhaps because of) marital ties between the two. Some of the settlements were almost perpetually at war with one another. The mixture of Ravens and Eagles at Koona seems to have been fortunate, for the

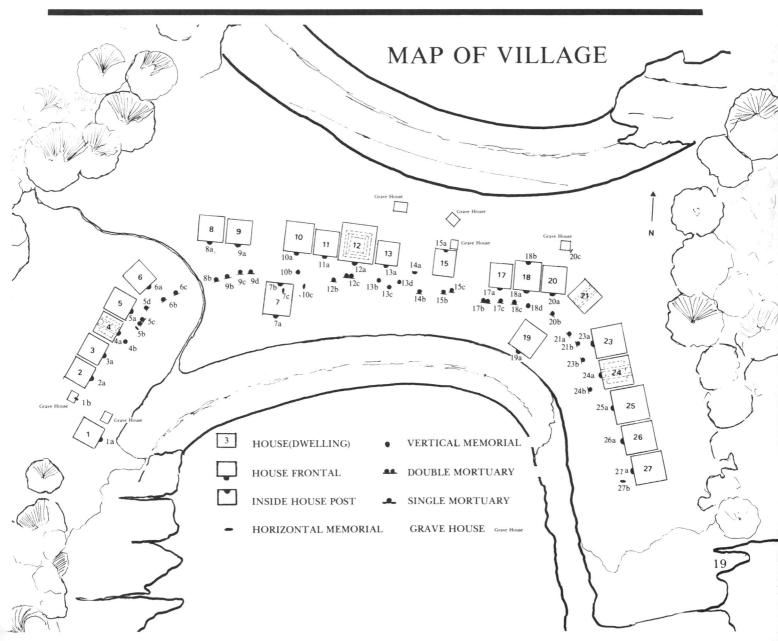

MAP OF VILLAGE

3 HOUSE(DWELLING)	VERTICAL MEMORIAL
HOUSE FRONTAL	DOUBLE MORTUARY
INSIDE HOUSE POST	SINGLE MORTUARY
HORIZONTAL MEMORIAL	GRAVE HOUSE

19

history of the village, according to the scant tradition that remains, has been termed extraordinarily peaceful.[4]

In Koona, the Eagle families were clustered together at the western end of the village bordering the creek. They occupied six of the twenty-seven houses and possibly a seventh which was not identified by family. Ravens occupied twenty houses at Skedans, extending eastwards out onto the peninsula. Chief Skedans himself was a Raven and his house stood in the center of the row.

We are given the names of the houses themselves and occasionally an indication of how the house name came to be chosen. Size, construction details, or a carving on the front gave some of the dwellings a name. Pride of ownership seems to have decided the issue in many instances and names such as "People Think of This House Even When They Sleep Because the Master Feeds Everyone Who Calls" could have no other

UNFINISHED CANOE

source. Many houses had several names, one perhaps more important than the others. And it is from Chief Skedans that we learn of yet another name for Skedans, "Xuadji lanas" or "Grizzly-Bear-Town", because of the large number of grizzly bears carved on the poles.[5]

Contact with the European traders had brought metal tools to the Haida, blankets and kettles, buttons and beads, hinges for doors, and smallpox. The disease reduced the native population to a fraction of its former numbers and wiped out some villages altogether. Koona did not escape.

In 1878, the village was photographed by George M. Dawson of the Geological Survey of Canada. His remarkable photographs (generously used in this book) form the first and best photographic record there is of Koona.[6] Here is the impressive row of community houses, the "thicket" of totem poles, the magnificent carvings still crisp and distinct, faded but not yet weathered or decayed. Dawson mentions only sixteen houses as being occupied against the twenty-seven original structures.[7] At first glance it would seem that the village was still sound in 1878, if reduced in size, but a closer examination of the photos shows houses becoming derelict; some already skeletons with wallboards gone and timbers mossy.

The village was not completely abandoned until a decade or so later when the last people living there moved to Skidegate. They had begun the long struggle to adapt themselves to the new world which had torn apart the fabric of their lives.

The autumn rains came to Skedans, as they had always done, but now no fires kept out the damp. The roofs leaked and were not repaired. Roof beams turned from gray to green with moss and ferns, whose roots held the moisture until the wood became sodden, crumbling with rot and tunnelled by woodboring insects. Conifer seedlings sprouted and bristled from every crevice, growing vigorously fifteen feet from the ground. Their roots grew and pushed, searching for the ground below, forcing apart the carefully mortised joints until the old wood and the new came crashing to the ground together.

In 1897, Dr. C.F. Newcombe of Victoria B.C. visited Skedans and filled his notebook with a rough sketch of the house frames and poles of the village. One or two of the smaller monuments he arranged to have removed on behalf of museums in Canada and the United States and he photographed some of the remaining poles, particularly those omitted from Dawson's plates.

Emily Carr, Victoria's well-known artist and writer visited Skedans about 1907. She too took a few snapshots with a small camera, apparently to stimulate her memory later on when she worked to recreate in oils her impressions of the old villages. Only one or two houses remained intact at that time, those which had been kept in reasonable repair as a temporary camp for halibut fishermen. All the other dwellings were in varying stages of collapse. Some of the poles were down. The majority still stood, and in *Klee Wyck,* she paints an unforgettably vivid and haunting picture in words:

. . . . They were in a long straggling row the entire length of the bay and pointed this way and that, but no matter how drunken their tilt, the Haida poles never lost their dignity. They looked sadder, perhaps, when they bowed forward, and more stern when they tipped back. They were bleached to a pinkish silver colour and cracked by the sun, but nothing could make them mean or poor, because the Indians had put strong thought into them . . .[8]

Years passed, and more poles fell. The house frames collapsed and a thick green blanket of moss covered their bones. Once in awhile a boat would enter the placid waters of the bay and geologists, fishermen, lumbermen, museum representatives or the occasional tourist would prowl the ruins, take a few photographs and continue on their way. There is very little left to see, the stubs of a few poles, one or two carvings, badly decayed. Soon only an archaeologist will be able to find any trace at all of this once complex, creative and vigorous community.

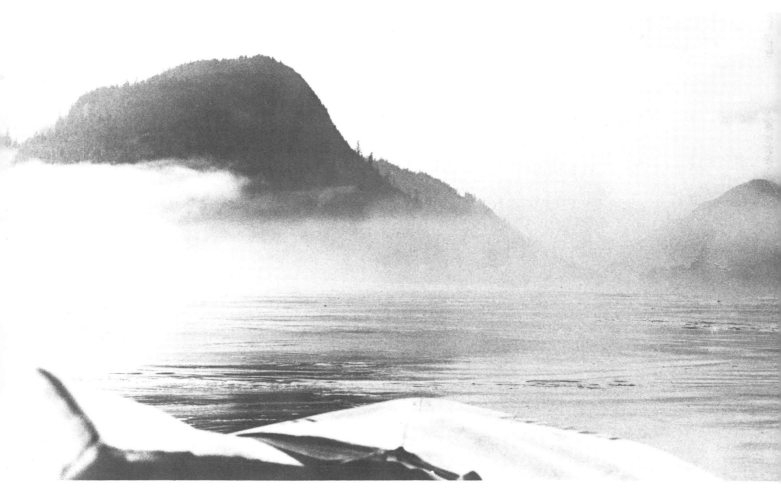

CHAPTER II
CLANS AND CRESTS

FROG TOAD CREST

The abandonment of the Haida villages in the 1890's marked the end of a way of life. The anthropologists came and talked to the old people in Skidegate and Masset and went away and wrote books. The children, heirs to the Haida oral tradition, were claimed by residential schools which took them far from the close home life they had enjoyed to a place with strange food and stranger customs, where they were made to speak a foreign language. They were taught from books, but never books about Indians. They became Christians for the most part, and were encouraged to forget the struggles for prestige and wealth which had once occupied their ambitions. The influence of Christian teachings suppressing motivation, and the levelling effects of mass education succeeded in wiping out an inestimable portion of the traditions of these people. That which scholars had written down was saved. That which some families managed to pass on to their children in the old way was saved. How much more was lost can never fully be assessed.

By 1935 when the City of Prince Rupert decided to salvage some of the totems of old Skedans and preserve them in the City Park, there was no longer anyone left alive who could identify the figures on the poles. When people asked as they

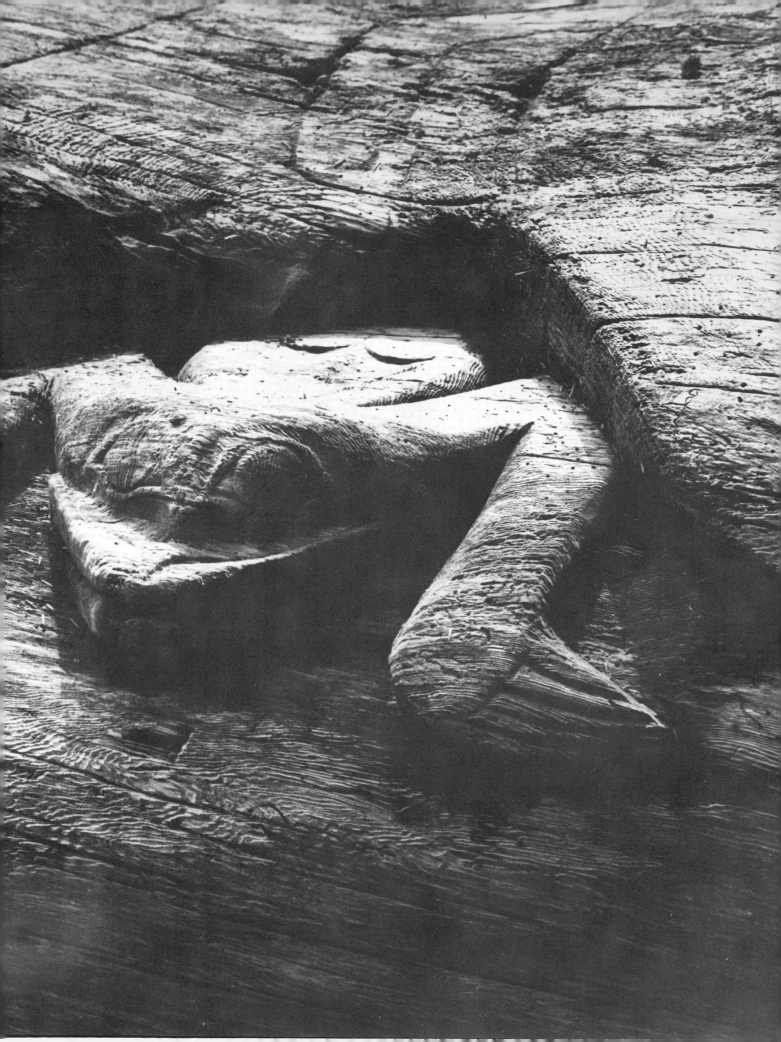

invariably did and still do, "What do the poles mean?" the answers had to come from the writings of anthropologists such as John Swanton.

He found the Haida to have resembled in some ways the Highland Scots. There had been some 17 major clans, each named after its place of origin, each strongly loyal unto itself but fiercely competitive with outsiders. Rivalry and competition were basic ingredients in the life of the people that often escalated into war. Each family strove with every other to amass wealth. Property was essential; that is, property in the sense of material objects. The Haida had no idea of ownership of land, simply the right to hunt or fish over certain areas. Houses and blankets, boxes and canoes, copper and silver ornaments, masks and feast dishes, an abundance of food and furs were necessary for a high-born family to maintain their rank, their dignity and their self-respect.

Even more important than wealth though tied to it, were the tribal privileges. Each chief "possessed" by purchase or inheritance the right to dance certain dances, sing particular songs, tell family stories and portray crests which had belonged to his clan for generations. There were very rigid rules governing these privileges. No one could tell another's story or portray another's crest without the owner's permission. Any attempt to borrow an idea or a design was an infringement of copyright, so to speak, or worse. It was considered a deliberate insult, an assumption of superiority and an outright invitation to do battle.

The same motives that prompt people to wear the clan tartan or to monogram the family silver moved the Haida to mark their property with their family crest. The Haida heraldic devices took the form of land animals; sea-creatures, birds, natural and supernatural phenomena, even man-made aritcles. The decoration was not art for art's sake. Each carving of a crest was tied in with the stories, songs, and privileges of the clan. The grave-house eagle of Koona, for example, was not just an ornament. It epitomised everything that was of value to the Haida: family connection, family privilege, family wealth, and family honour.

Because crest carvings are essential to the understanding of the totem poles it might be as well to discuss them briefly here, with reference particularly to the clans and families living in Koona. The two Eagle families in the village were branches of the clans called Those-Born-at-Koona, and the Djigua-Town-People. Other branches of the same clans lived in other villages. The eagle was their most important crest but it was by no means the only one. Those-Born-at-Koona had the right to represent the crests illustrated below and at right. The Djigua-Town-People, possibly a subordinate Eagle clan, could use the same crests only if they could get permission.[9]

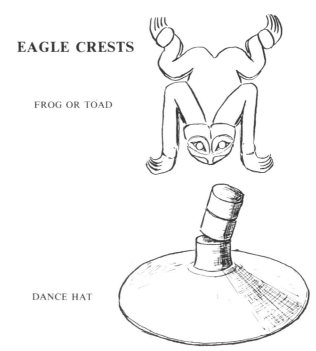

EAGLE CRESTS

FROG OR TOAD

DANCE HAT

DOG AND HUMMING BIRD — NO KNOWN ILLUSTRATIONS

The three Raven families at Skedans all used the same crests except for the moon, which was reserved for the chiefs of the clan known as Those-Born-at-Qagials. The Peninsula-People, and the People-of-the-Town-in-McKay's-Harbour were entitled to use all the other crests.

There were other Eagle and Raven crests besides these and they are listed opposite. Through intermarriage with other families, some other crests appear on the Skedans poles but the ones shown here are the most common.

EAGLE CRESTS

EAGLE

COPPER

CORMORANT

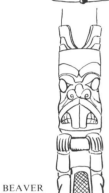

BEAVER

DOGFISH

BLACK OR
ORDINARY
WHALE

RAVEN CRESTS

MOON WITH LABRET
INDICATING
WOMEN
OF HIGH RANK

MOUNTAIN
GOAT

KILLER WHALE

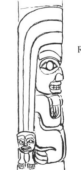

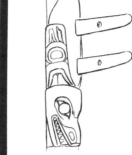

RAINBOW

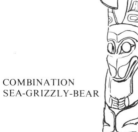

GRIZZLY BEAR

COMBINATION
SEA-GRIZZLY-BEAR

CHILD OF PROPERTY WOMAN — NO KNOWN ILLUSTRATIONS

ADDITIONAL EAGLE CREST FIGURES

SCULPIN	QINGI'S HAT
RAVEN	STAR BLANKET
HALIBUT	ABALONE
SEA NU	CEDAR LIMBS
HERON	MICA
WASGO	MARTIN HAT
DRAGON-FLY	YELLOW CEDAR-BARK
STARFISH	FIVE-FINNED KILLER-WHALE
CUMULUS-CLOUD	
WEASEL	
BLUE HAWK	
DOG	
SKATE	
T OF COPPER	

ADDITIONAL RAVEN CREST FIGURES

TCA MAOS	SEA-LION'S HEAD
SEA-LION	NEW MOON
THUNDER-BIRD	STAR
CUMULUS-CLOUD	CIRRUS-CLOUD
DOG-FISH	STRATUS-CLOUD
WOLF	ABALONE-SHELL
FLICKER	DENTALIUM CARVINGS
RAVEN	GADJI
HAWK	DRYING FRAME
TREE	WEASEL
GITGA LGIA	HORNED OWL
RAVEN-FIN	SKATE
BLACK BEAR	WORM
BLACK BEAR WITH ABALONE	

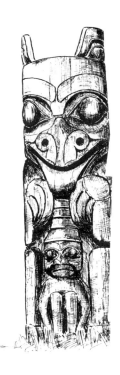

BEAR GUARDIAN
AND CHIEF

crest figures in the design of a carving. When a pole was to be undertaken, the owner commissioned a master carver, and to him he confided the history of the family ties and the particular stories associated with the family he wished recorded. The carver assimilating this wealth of information, had the task of converting it into a design, an "ideogram", where the very size and position of the figures were significant. If a large bear held a man upright (upper left), for example, it might indicate that the man was the chief, embraced and protected by his guardian totem, the bear. On the other hand, if the bear held a man upside down (lower left), it might mean that the chief's guardian totem had helped to ridicule or put to shame an enemy, and the enemy was shown upside down as an insult. If the bear was shown eating a man (upper right), it might recall the legend of the hunter who was attacked by a bear. If the bear was shown with an arm around each of two cubs, (lower right), the legend of Bear Mother and her two supernatural cubs might be indicated. The carver then, had the responsibility of designing a pole which would include those ideas the owner wished recorded for posterity.

Attempts are sometimes made to "read" a totem pole as though one story connected all the figures on the pole. This was seldom the case. The figures were indirectly related in the sense

Each crest figure had a number of legends which accompanied it and described how some ancestor of the tribe had a dream or an experience involving the crest figure which he then adopted as his own personal guardian spirit and identifying crest. Many of the crest figures were supernatural beings having the power to change themselves from animal to human and back again at will. Or they represented some mythical ancestor of the clan who was turned into a rock or a cloud or a killer-whale through some magical occurrence. While the origin of the crest may have been magical, the crest figures in everyday life were heraldic privileges. They identified the family.

Story figures also appear in carvings. These were not crest figures as such, but accompanied the crests and served as illustrations to the family trove of legends, myths and adventures. On the poles, the story figures were usually much reduced in size from the crest figures which dominated the pole. Little figures might tell of the courageous deed of a famous ancestor, of a battle won, of a debt owed and repaid, of a murder avenged, or a quarrel with a mother-in-law, or a prank that backfired. A small figure might also represent a spirit power which had given supernatural strength or wisdom in time of great need.

The story figures were often mingled with the

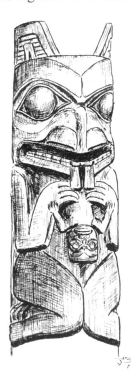

BEAR GUARDIAN
TOTEM HOLDING
ENEMY UPSIDE
DOWN TO
RIDICULE HIM

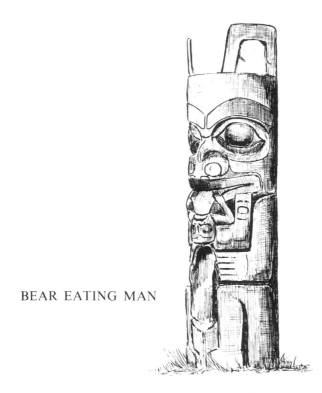

BEAR EATING MAN

that they each belonged to the owner of the pole, but they did not necessarily relate to each other.

When the totem poles were abandoned in the villages, the first figures to be forgotten were the small story figures. By 1897, Dr. Newcombe found difficulty in getting an explanation from his Indian informants for the "filler" figures as they came to be called. He assumed, as have others, that these smaller designs had "no significance", but in our opinion a more correct interpretation would be that they were less important than the crest figures and were perhaps recognizable only by the carver and by the owner of the pole. When the owner died, the meaning of the story figure died with him.

Once the Haida people had gathered in Skidegate and Masset, they were exposed to even greater contact with European traders, missionaries, and government officials. The old organization was so disrupted, the authority of the chiefs and shamans so weakened, that the tribal beliefs and customs could not be enforced. English laws which were enforced had no relevance. In an attempt to become strong and respected once again, the Haida turned their backs on the old ways which had been made to look foolish, and attempted to divert the current of their beliefs into European channels.

The habit of carving during the winter months

did not die easily. But by the 1900's, without the support of traditional beliefs, the large totem monuments were no longer being produced, and some were actually destroyed for firewood. One generation passed, and the techniques of designing and carving the enormous figures were lost. The Haida turned almost exclusively to argillite, the dark grey slate which is found in the Queen Charlotte Islands, and which the Indians had been carving for some years as souvenirs for tourists. However, the rigid rules and careful apprenticeship of former years was relaxed. Subjects were chosen for artistic appeal without any reference to their original purpose, and the careful precise form-lines of the old style of carving soon became loose approximations.

Thus, through the early years of the twentieth century some crest and story figures became popular as designs, others fell into disuse and the accompanying stories were lost. A modern carver may know a goodly number of crests and the legends that accompany some of them. He can still choose from a wide range of figures and ideas, thanks due in part to the renewed interest in the art form. But when faced with one of the old poles, he may only be able to shake his head in defeat. The illustration is there, but the story is gone.

It is no longer possible to know exactly what the figures on the old poles mean.

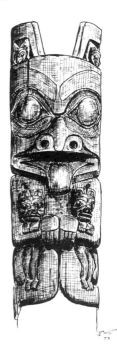

BEAR MOTHER WITH
TWO CUBS

CHAPTER III
TOTEM POLES

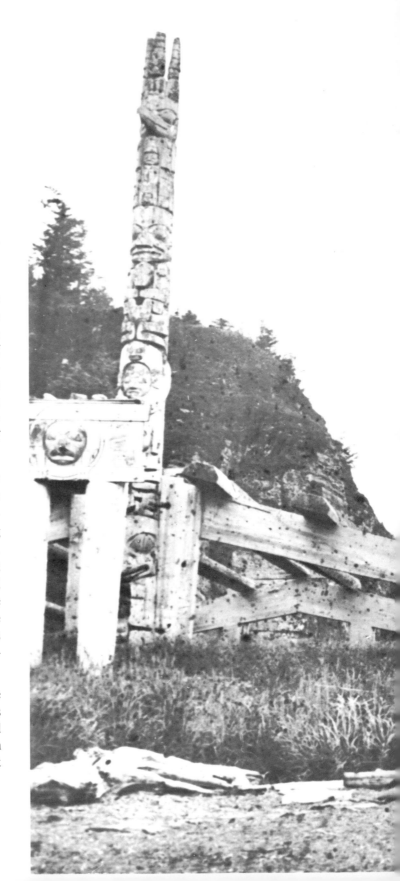

SKEDANS 1878 DAWSON

In 1954 when a museum salvage expedition at last arrived in Skedans, it was almost too late. Of the fifty-six carved monuments which had ringed the bay in 1878 like a line of warriors, only eleven remained erect. An invading army of trees had broken through the ranks in a slow-motion struggle for possession of the shoreline, and the trees had won. They marched over and around the rotting hulks of poles, split, fallen, and decayed.

The *house frontals,* sometimes reaching fifty feet in height by five feet in diameter, seem to have suffered the most. They had been hollowed out at the back to keep them from splitting and to reduce their weight for easier erection. The older poles had doorways cut through at the base, which further reduced their structural strength, and once the house behind became derelict, it was not long afterwards that the house frontal fell. Only two house frontals remained standing in 1954 and these were salvaged and removed.

The carvings on the house frontals depicted the geneological crests of the house owner and his wife, and each side chose crests which traced their lineage and gave their social status. In Skedans, the house owner's most important

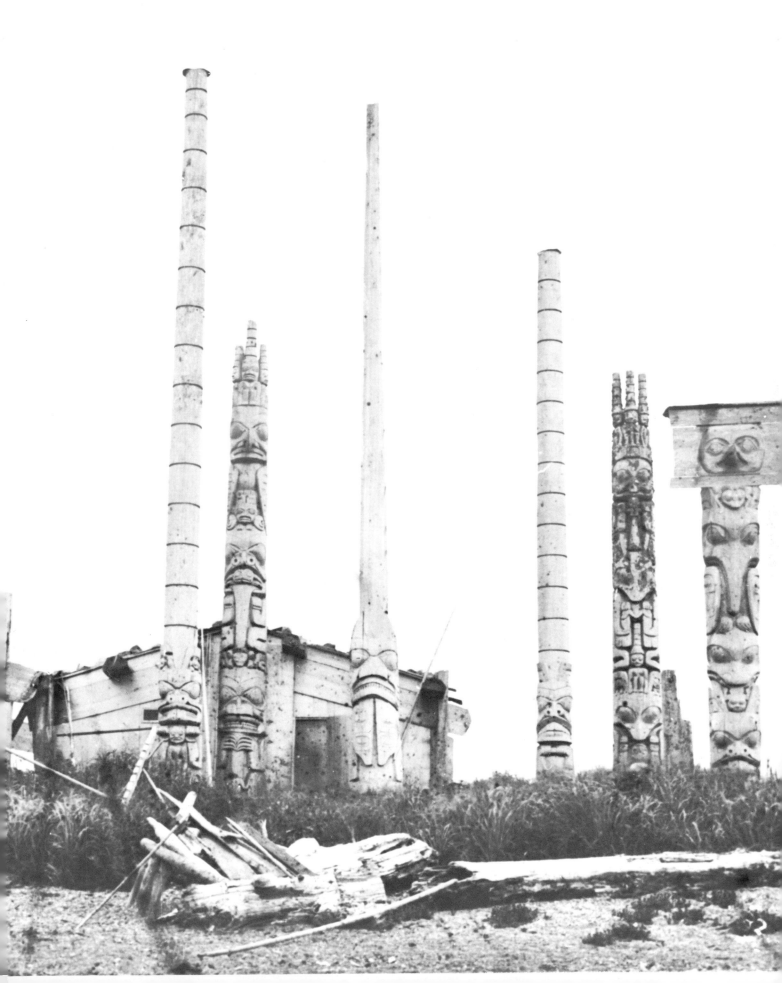

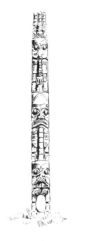 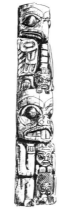

HOUSE FRONTAL INSIDE HOUSE POST

crest invariably appeared at the bottom of the pole, surrounding or adjacent to the main entrance to the dwelling. Contrary to popular belief, being "low man on the totem" was not a position to be despised.

A few dwellings had an *inside housepost,* a hollow-backed pole set at the rear of the house under the peak of the roof. It did not actually support the roof beams but served simply to display the crests of the house owner or his wife in a position of honour behind the chief's bench or chair. Of the three such inside house posts at Skedans, two were removed to museums, their smaller size making the task of moving them less arduous. The one that remained at the site has fallen forward and split in two.

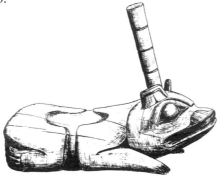

HORIZONTAL MEMORIAL

The *horizontal memorials* suffered a similar fate. There were four at Skedans originally, of which two have been preserved in museums. One has disappeared entirely and is presumed to have been removed from the site, and the other, barely recognizable, is fast forming part of the soil at the eastern end of the village. These memorials, sometimes called grave-box

supports, were almost certainly carved to commemorate a dead person of high rank. They were the only true large three dimensional sculptures of the village, for the totem poles themselves are not carved in the full round.

The *vertical memorial* posts, sometimes more than fifty feet in height, usually had only one large figure below with a tall slender uncarved shaft above. They were erected to commemorate the dead. In Skedans, the shafts were either divided into segments to represent a property hat, or were squared off to represent an enormous dorsal fin rising from the head of the base figure. There were only six of these originally, and two of them are still standing at Skedans. One has fallen and the others have completely disappeared.

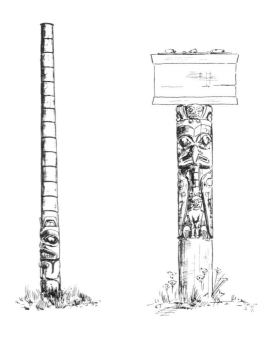

VERTICAL MEMORIAL SINGLE MORTUARY

Ten of the original eighteen *single mortuary posts* remain standing at Skedans, although the board frontals have now gone. Single mortuaries could be described as elevated tombs, with the upper end of the shaft formed into a chamber to receive a burial box. For this reason, the log was placed in the ground with the wider butt-end, upwards. About four feet of

the top end was hollowed out for the box and the hole was covered at the front with a horizontal carved panel depicting the crest figure of the deceased. A plank weighted with boulders served for the roof. The support post itself might be carved with figures, fluted in long vertical channels, or left plain. Some of the support shafts at Skedans, plain and carved, remain standing, but all the carved and painted front panels have disappeared. Some of these have found their way to museums, some may have been removed by collectors, but most of them have no doubt simply dropped off and decayed.

DOUBLE MORTUARY

An unusual type of mortuary at Skedans was the *double mortuary* which consisted of two plain upright posts about nineteen feet high, set three feet apart. A shelf was placed between the posts about four feet down from the top and on this shelf the coffin rested. The whole upper section was then boarded up; top and back with plain planks, the front with a carved panel. One such front panel, the last mortuary panel to survive in Skedans, finally fell, probably during the winter of 1967. The next year it was illegally removed and only the alertness of the R.C.M.P. prevented its disappearance out of the country along the same route taken by so many of its fellows.

All the poles had been carved on the ground, with long-handled adzes and axes being used to strip away unwanted wood. The smaller hand-adzes were employed to do the finer shaping and finishing and to smooth the surface of the wood. The incised lines which defined eyes, eyebrows, lips, feathers, flipper-designs and so forth were put in with knives. These knives were originally stone-bladed but gave way to metal-bladed tools when these became available. The important features on the carving were highlighted with paint. Charcoal, crushed clam shell, iron oxide and copper ores, ground and mixed with salmon eggs, gave black, white, red and blue, but the Indians turned happily from these natural pigments to the bright and garish commercial paints they could obtain in trade. They did not attempt to re-paint poles previously erected, and these were left to the natural process of decay.

The carving and the ceremonies attending the raising of the poles were all-important and formed a major event in the lives of the family. When the guests and workers were assembled and the hole dug, the uncarved lower portion of the pole's base was slid into the excavation. Levers were employed to raise the upper portion and props of increasing length were inserted until the pole was upright. When block and tackle became available, a framework of lighter poles was built from which the tackle was suspended and around which ropes could be snubbed to keep the pole from slipping as the workers hauled it up. Once the pole was erect, the hole was filled in with the heaviest boulders which could be conveniently moved to the site and well-tamped down with smaller boulders and earth. The packing was effective in weighting the lower end of the pole against wind-stress and provided good drainage as well. Few poles ever seem to have been uprooted. Most of those that have fallen have rotted off at ground level, or indeed, rotted almost entirely before falling. But some have stood for more than a hundred years without ever being repainted or repaired.

Lest governments and scholars be unduly criticized for not taking steps to ensure that all remaining poles are somehow "preserved", it must be pointed out that the problem is far from a simple one. In the first place, the totem monuments which are left, are for the most part mortuaries and memorials which correspond to tombstones in western European culture. To remove them from the place they

mark merely because they are also valued works of art, is not in keeping with their original purpose.

To leave them in the deserted villages where they belong is to ensure their eventual disappearance. There is as yet no practical means of "fossilizing" a totem to protect it indefinitely from the weather. Heavy coats of paint protect the surface to a degree, but do nothing to halt the ravages within. Impregnation with chemicals is possible but difficult and expensive in remote areas where conditions are far from "controlled." And besides the natural forces of weather and decay, there are the collectors and vandals to be considered. The sites are protected by law, but the penalties for disobeying the law cannot be handed down unless the culprits are brought to court. The costs of supervising the sites on a year-round basis have been prohibitive.

Then too, the forests which have grown up around the sites are ready for harvesting. The last four years have seen the establishment of a base camp for a logging operation on the Skedans peninsula and their plans originally called for dumping logs straight into the bay in front of the village, meaning of course, that roads and camp space were to be carved right out of the village site itself. The logging company was approached by a representative of the Provincial Museum before any such clearing was undertaken and very obligingly, the company moved its operations to the north beach, leaving the site unscathed — for awhile. Then the road was pushed through. The more sheltered waters of the southern bay proved too attractive to resist. How much archaeological evidence has been destroyed cannot possibly be estimated.

The alternative to leaving the poles alone seems to be to remove them and have the originals copied by competent native craftsmen, trained in the old techniques. This approach has been tried with great success in a number of places: Masset, Victoria, Vancouver, and 'Ksan — to name only the better known projects. In most cases, the artists have copied poles, the copy has been put on display locally, and the

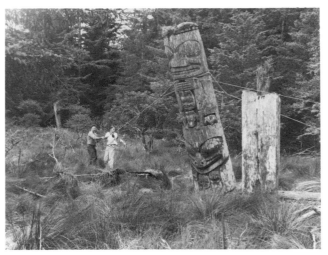

NINSTINTS VILLAGE RECOVERY EXPEDITION. FIRST LOWERING POLE

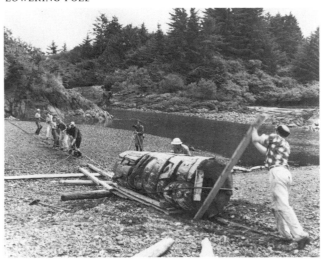

POLES WERE THEN DRAGGED TO THE BEACH, AND CRATED FOR SHIPMENT TO THE PROVINCIAL MUSEUM IN VICTORIA.

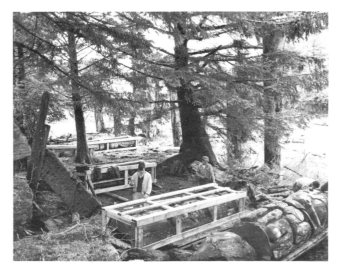

PROVINCIAL GOVERNMENT PHOTOS.

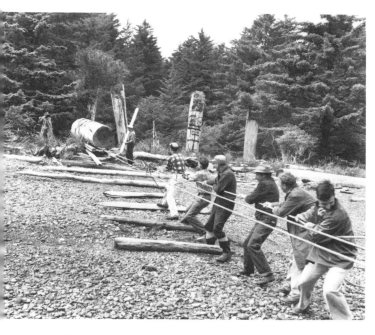

original kept in storage, carefully maintained for study and research in one of the major museums in Victoria or Vancouver.

Even this policy has raised some objections. The people of the Queen Charlotte Islands, quite understandably, resent the wholesale removal of these unique monuments from the Islands that fostered them. They feel that although permission for removal has been obtained from the Indians themselves, band leaders have been unduly influenced by government officials. Even the copies produced by modern craftsmen

are not a substitute for the original poles carved within the framework of the tradition and certainly the Queen Charlottes should never be deprived of all the originals.

There is also a minor question of aesthetics to be considered. Those poles which have been removed to museums for safekeeping and preservation look out of place and often grotesque indeed in modern surroundings. Not much can be done to make a forty foot totem pole look at home with carpeting and concrete.

In the meantime, while the pros and cons of every alternative are weighed and discussed, the old poles sink a little further towards oblivion. For all that, perhaps not every old pole can be or should be saved. Many are beyond saving in any case, but there are those persons who argue, with reason, that a representative selection is sufficient.

A record should certainly be made, however, of every single British Columbia totem pole, past and present and catalogued in a thoroughly scientific manner. In this way, the totem pole villages of the past could be preserved permanently for future generations by camera and pen rather than by more immediate physical means.

ONE OF THOSE BORN AT KOONA NOW RESTS IGNOMINIOUSLY ON ITS TAIL IN MUSEUM

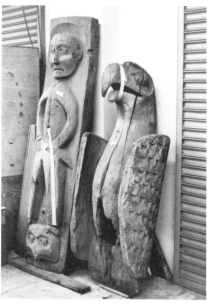

CHAPTER IV
THOSE BORN AT KOONA
The Descriptions of the Poles

1 LAND OTTER HOUSE

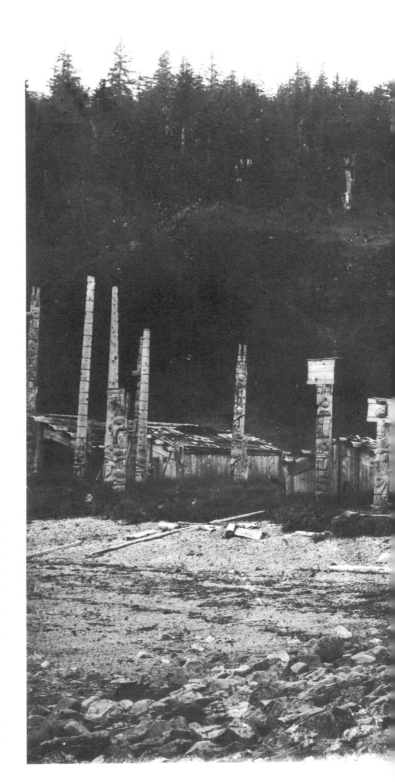

SKEDANS 1878 DAWSON

The Eagle grave house at the western limit of the village was set well up on the slope overlooking the bay. Somewhere below and in front of it stood the first Raven family house, "Land Otter House, named after a carving,"[10] but no photographic record of the house or carving remains.

George M. Dawson, whose series of remarkable photographs is the source of most of the illustrations in this book, somehow failed to record the extreme western end of the village. Whether the plate was spoiled or whether he simply never photographed that far down is not known.

1a HOUSE FRONTAL

Dr. C.F. Newcome, who visited the site in 1897, indicated the presence of a house frontal pole in this location in his short-hand sketches of the village. He draws a column, with three vertical pencil strokes on top which represented the three watchmen ("three johnnies" as he called them). The column leans forward sharply, propped with a few poles to keep it from falling. Both the house and the house frontal pole have long since disappeared.

1b EAGLE GRAVE HOUSE MARKER

Between the first dwelling and the second was the small Eagle grave house illustrated and described on pages 10-11. ·

34

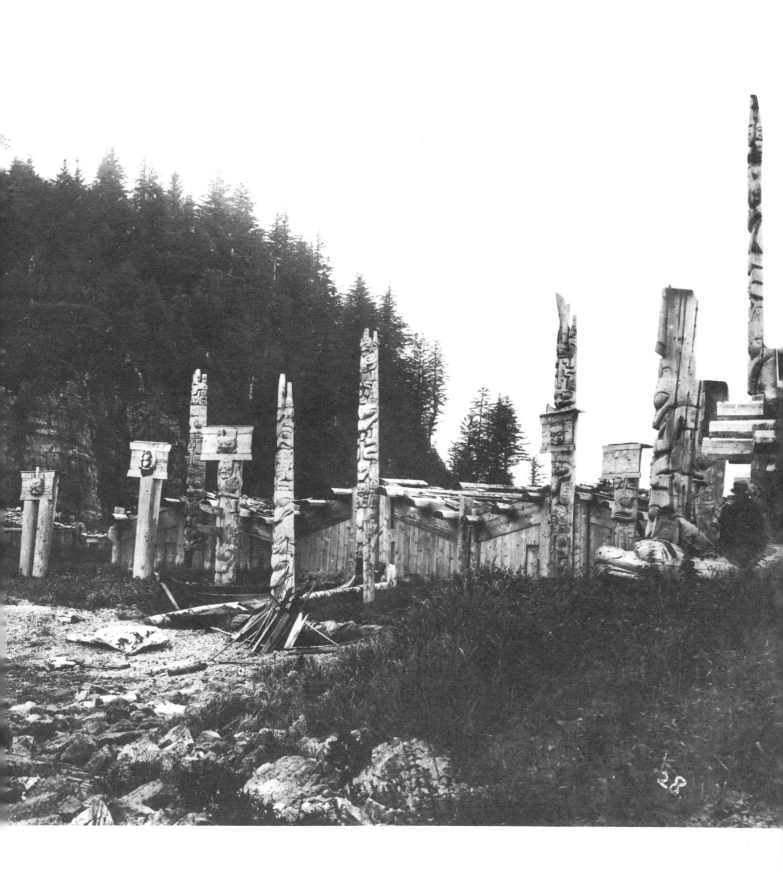

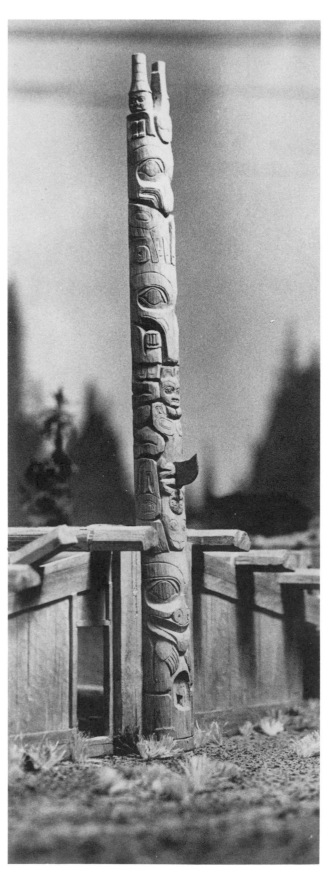

2A

2 HOUSE RAVEN FOUND

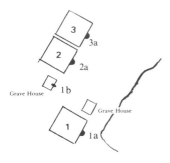

2a HOUSE FRONTAL

The second house at Skedans was called "House Raven Found" and also belonged to a Raven family from the clan called "Those-Born-at-Qagials."

At the very top of the pole are two watchmen wearing conical hats. Between them is a small figure of a killer-whale, his dorsal fin sticking up like a third hat. Watchmen were said to be placed on top of poles to warn the house owner of approaching danger,[11] and usually face outwards.

Below them are the four main crest figures of the pole, and from the top these are the eagle, the raven, the killer-whale and the grizzly bear. The eagle, and surprisingly enough the raven as well, were Eagle phratry crests, likely those of the wife of the house owner. The raven actually belonged as a crest figure to both phratries, but was a more important Eagle crest. No one knows why this should be so. The eagle at the top is shown with a turned down beak and wings folded forwards. The raven just below, is a long-billed semi-human figure with feathers appearing on his human elbows and with knees and feet rather than talons. His human limbs indicated his ability to change himself into human form.

The Raven crests of the house owner, the killer-whale and the grizzly bear, are portrayed on the lower half of the pole. The killer-whale is shown head downwards, his pectoral fins turned upwards along the sides of the pole and his flukes

fanned out below the raven's knees. The flukes are clutched by a semi-human figure, and a second human figure rides upside down on the whale's back holding onto the dorsal fin. The fin itself, once a separate piece, has fallen away leaving only the mortise hole to show its position.

These two human figures are often associated with the killer-whale but are usually admitted to be of "uncertain significance,"[12] for the killer-whale appears time and time again in Haida mythology. Any number of heroes rode or hunted, killed or were killed by the "scana." There was also a popular belief that drowned persons were transformed into killer-whales.[13] The two little human figures may therefore be the visual representation of any one of several ideas or stories, or more simply, may indicate a member of the clan in possession of his family crest.

The lowest figure on the pole, the grizzly bear, is an excellent example of this animal as portrayed by Haida artists. Although the carvers were quite capable of producing a more realistic likeness, custom bound them to depict crest figures in a particular way. The bear's ears, for example, instead of being small and round were tall and square and served simply to indicate an animal nature. All land animal crests were shown with ears of this kind. The bear's distinguishing characteristics were perfectly round nostrils, a wide, upturned mouth and protruding tongue, and paws which were raised up to the chest as a bear holds them when he rears up to investigate.

DUFF 1953

2a

KILLER WHALE WITH TWO RIDERS

In the bear's stomach, a traditional door-hole had been begun and never finished, suggesting that this pole was raised after white men's doors had become familiar. The house, now vanished, probably had a hand-made hinged door in the front of the house just beside the pole.

The column stood about 36 feet high, but was cut into sections in 1954 to facilitate its removal to the University of British Columbia. It has been preserved there as part of a totem pole rescue and restoration project with the approval and permission of the band council at Skidegate who represent the descendants of the original owner.

POLE 2A

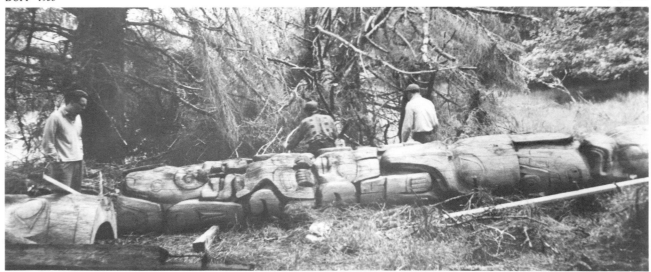

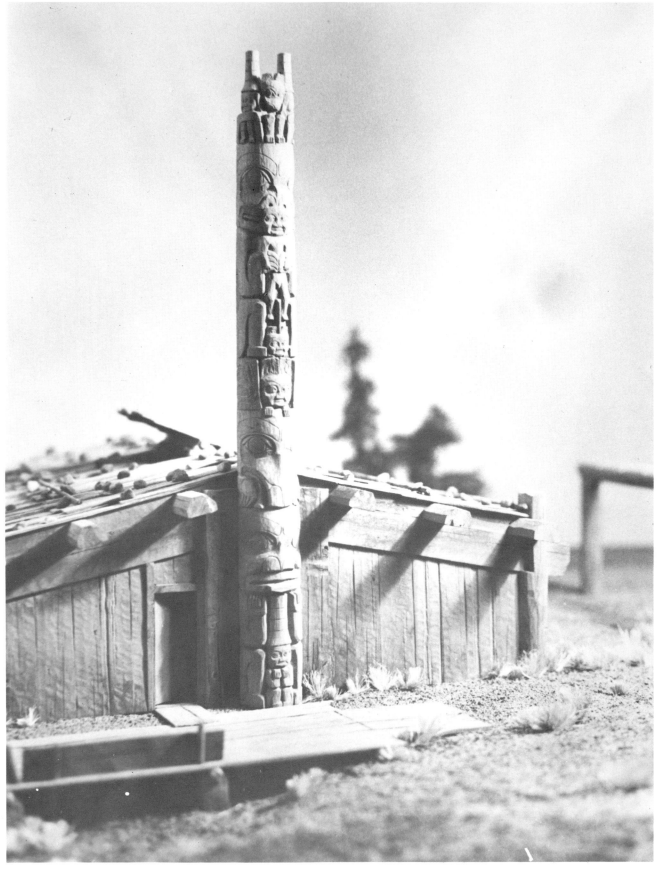

3 HOUSE MOTHER

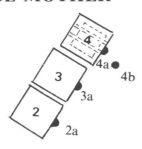

3a HOUSE FRONTAL

The third house in Skedans was known as "House Mother" and belonged to a Raven family. The house frontal portrays three main crest figures whose identities are very difficult to ascertain without information from the carver or owner.

The large top figure has been identified in the past as Bear Mother,[14] a story figure rather than a crest, depicting the woman who became part bear after marrying a grizzly bear. She is usually shown as a bear holding two little men (her sons), or else as a woman holding two bear cubs. Here the main figure holds only one figure and a bear cub perches overhead.

An almost identical grouping on a Tlingit pole, however, has quite a different interpretation. There the main figure is a man, Kats, the bear hunter, whose bear wife is shown over his head. The man being held and the small face at his feet on the Tlingit pole, belong to an entirely different story.[15] We feel the same must be true here. The man being held probably belonged to the grizzly bear crest and had an encounter of

some sort with the creature represented at his feet, which is shown with animal ears and a small dorsal fin rising above its forehead.

The second major grouping, just about the center of the pole, is more obviously a crest figure. It is a long-billed bird, probably the cormorant, whose talons are curled around each side of its beak. The animal 'ears' which rise above the forehead are much longer than is usual and may be intended as wings. Over the cormorant's forehead is a human wearing the two feathers which denote supernatural powers. A Haida hero called Stone Ribs used the cormorant's skin to fly and this little face may be Stone Ribs peering out from within the cormorant's skin.

The large figure at the bottom of the pole is that of a woman, and must surely give the house its name of "House Mother." The lip-plug, indicated here by a wooden block nailed on the lower lip, was worn by Haida women of high rank, and its presence on the pole probably means this figure was an ancestress of the clan or a chieftainess of particular importance. Between her hands she holds the "skil" or property hat of the small figure at her feet, who may be the chief who erected this pole.

This house frontal, about 36 feet high, was another of the poles collected by the Provincial Museum in 1954 with the permission of the Skidegate Band Council. It had fallen and was badly decayed but the top portion was salvageable and now forms part of the collection at the University of British Columbia.

POLE 3A

NATIONAL MUSEUM PHOTO

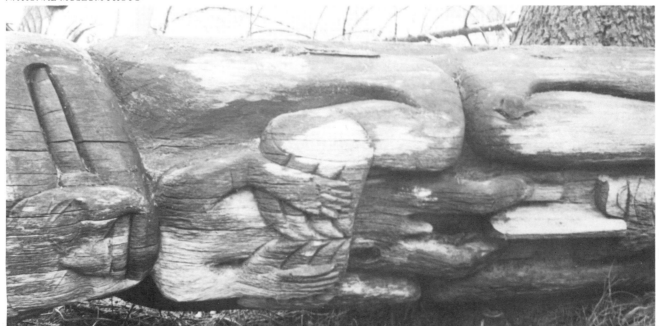

39

4 MOON HOUSE

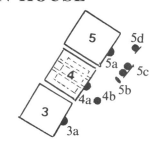

4a MODEL HOUSE FRONTAL

Most of the great houses of Skedans had six enormous roof timbers, three on either side of the ridge, whose ends overhung the gable walls by several feet. The fourth house from the western end of the village, however, was of totally different construction. Only two major roof rafters were employed, set about twelve feet apart, the ends supported by massive posts. The reason for this difference in construction is not known, but all the two-beam houses seem to have been built at a later date and certainly used fewer materials. (see page 102).

On Chief Skedans' list, the fourth house had been rebuilt several times, one house replacing another over the years. The most recent house had belonged to a Raven chief who had the right to the moon emblem as a crest, and the house, besides being called "Moon House," had the emblem of the moon on the front.[16]

Unfortunately, the houses did not appear in Dawson's photos of 1878. By the time Dr. Newcombe photographed that end of the village in 1897, the house frontal had disappeared and the house had all but disintegrated, except for the two roof-beams and their supporting posts.

Dr. Swanton, however, had had a model pole carved for him in Skidegate in 1900 which was supposed to be an exact copy of one at Skedans. Swanton[17] describes this model as follows:

> . . . the model of a pole belonging to Ni swas, chief of Those-born-at-Qa gials of Skedans, whose wife was Sqaan qaiyas, a woman of Those-born-at-Skedans The beaver and the eagle at the top were crests of Those-born-at-Skedans. Below the second of them is a figure intended to represent the moon; and under that, a grisly bear. They belonged to Those-born-at-Qa gials.

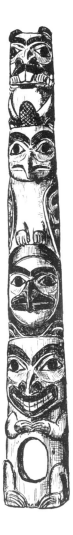

POLE 4A

Because no other pole in Skedans has this combination of figures, and because the model pole included the moon crest, we are including a drawing of the model[18] here as a possible illustration of the missing Moon House frontal.

If this model is an exact copy, as stated, and not just an approximation drawn from the carver's memory, then it would be the only such pole in Skedans to have a beaver crest appearing at the top. On all the other frontal poles where they are included they appear at the base.

It is difficult to surmise what may have happened to the original Moon House frontal. If it had simply fallen from decay, it should have been mentioned by Dr. Newcombe who faithfully recorded every prone pole he noticed.

4b SEA-GRIZZLY-BEAR MEMORIAL

If all the figures on Haida totem poles were well-known animals, birds or fish, our task of identifying them would be simpler but not so interesting. The creatures which appear, however, pay tribute to the vastly creative imaginations of the Haida storytellers who combined the fearful elements of the real world with the terrors of the unknown supernatural world to produce monsters of most horrible aspect. These same monsters, translated into masks and totemic figures by the carvers, are equally a mixture of the real and the "unreal."

One of the best known creatures, for example, combined the attributes of two very dangerous living beasts, the grizzly bear and the killer-whale. This "sea-grizzly" became a crest of the Raven clan and was widely used, but its form varied. Sometimes it had a whale's head with a bear's body; sometimes a bear's head with a whale's body; sometimes both bodies shared a single head; sometimes there were more subtle combinations of the two principal figures.

This memorial pole at first glance appears simply to be a grizzly bear holding a small killer-whale in front of his chest. As both the grizzly bear and the killer-whale are crests singly, as well as in combination, it was possible that the principal figure was only that of the grizzly bear. When the pole is viewed from the side, however, the bear takes on a different aspect. The shaft of the pole rising straight up from the bear's head suddenly appears as a huge dorsal fin, and provides the clue to the sea-grizzly's identity. The small killer-whale in front, its flippers folded back over the bear's elbows, is intended to act as reinforcement to the whale half of the sea-bear's nature.

This memorial pole stood in front of "Moon House," and had fallen when the site was visited in 1957. Only the upper uncarved section, the squared off dorsal fin, was identifiable.

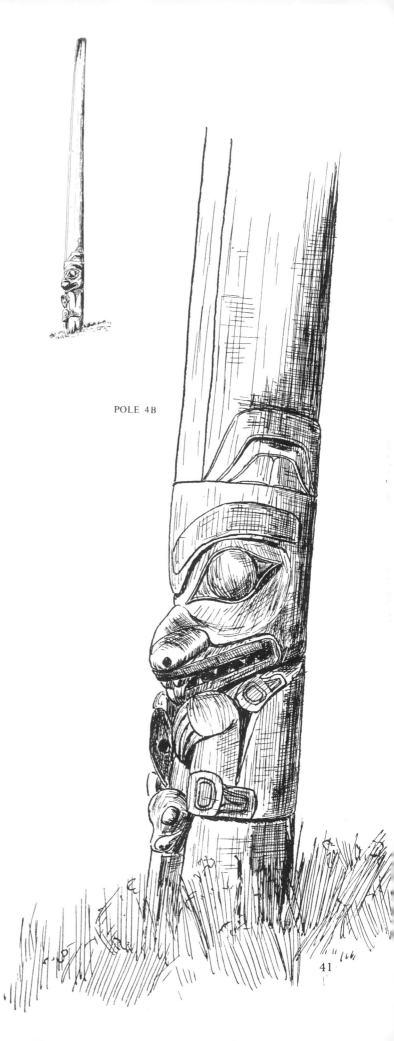

POLE 4B

41

5 EAGLE-LEG HOUSE

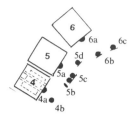

Of the twenty-seven houses named by Chief Skedans in 1900, six belonged to families of Eagles and were clustered together near the western bend of the bay. "Eagle-Leg House" was the first of these Eagle houses belonging to a family of the "Djigua-Town-People."

5a HOUSE FRONTAL

The top figure, crowned with three watchmen, is a fine example of the eagle crest. It has the traditional semi-human eyes and eyebrows. A projecting beak, separately carved, has been mortised into the face. Unlike the straight, sharply pointed raven's beak, or the hawk's beak which makes a U-turn back into the bird's mouth, the eagle's beak just hooks down at the tip. His wings, worn almost like empty coat sleeves, are folded forward. His talons, curled around, appear in the ear spaces of the raven below.

Sitting in front of the eagle crest is a little human figure, wearing on his head the two long feathers which seem to be used by the Haida artist when he wishes to indicate that the figure is possessed by supernatural powers. Here he might be a shaman who wore a coat of eagle feathers which enabled him to fly or he might be Eagle in human form.

The next major figure in the center of the pole is probably the raven in semi-human form. This long-billed bird appears time and again on Haida poles and might be any one of several bird crest figures. There is very little difference between them. By a process of elimination more than anything else, we have decided that when the bird has feathered arms and human legs it is most likely to be representing the trickster Raven who was able to change himself at will into a human form.

The large Raven figure is also linked with a "spirit figure", which he holds between his knees, either Raven in human form, a shaman or a legendary hero.

The bottom figure, the black whale, is an Eagle crest. He has the traditional semi-human face, lacking animal ears to indicate a sea-nature. Instead of a nose, the whale is given a broad snout, and his flippers, or pectoral fins, are folded forward almost like wings to conform to the shape of the pole. The doorway to the house was cut through his body.

The pole stands no longer, but its rotting hulk remains at Skedans, slowly dissolving into the youth and vitality of the new forest.

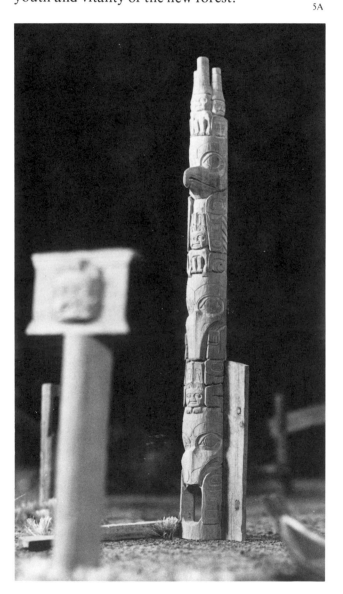

5A

5b WOLF HORIZONTAL MEMORIAL

When Dr. Newcombe visited Skedans in 1897 and roughly sketched the poles of the village, he gave no indication of the horizontal memorial figure which appears in his photographs. It is possible that while concentrating on the magnificent row of standing poles he failed to notice it behind him in the long grass, for it stood well away from the buildings, almost on the edge of the beach.

These horizontal carvings were sometimes used to support grave boxes but when they were out of doors, as this one was, they were more likely to have been a memorial to a departed relative.

In the photograph the lower part of this creature was hidden in the grass, and the hindquarters were lost behind another pole, making the identification of this figure even more difficult than usual. The head appears longer and the ears taller than is customary for a bear, so it may possibly be a wolf, a crest of the Raven clan.

This horizontal memorial, one of four originally at Skedans, seems to have disappeared from the site. The remains of another were just identifiable in 1957 though badly decayed and two others have found their way to American museums.

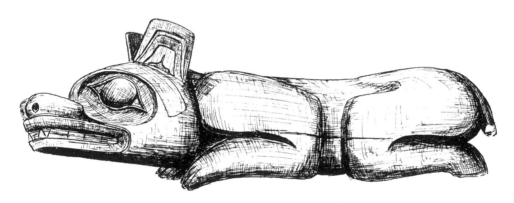

POLE 5B

PAGE FROM DR. NEWCOMBE'S NOTEBOOK 1897

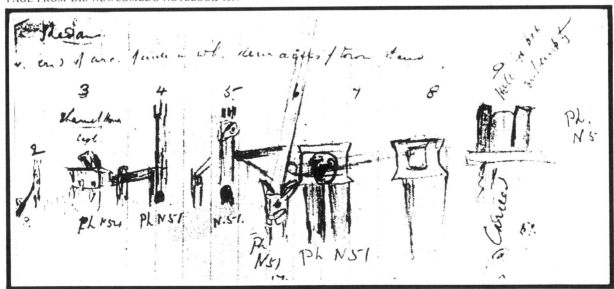

43

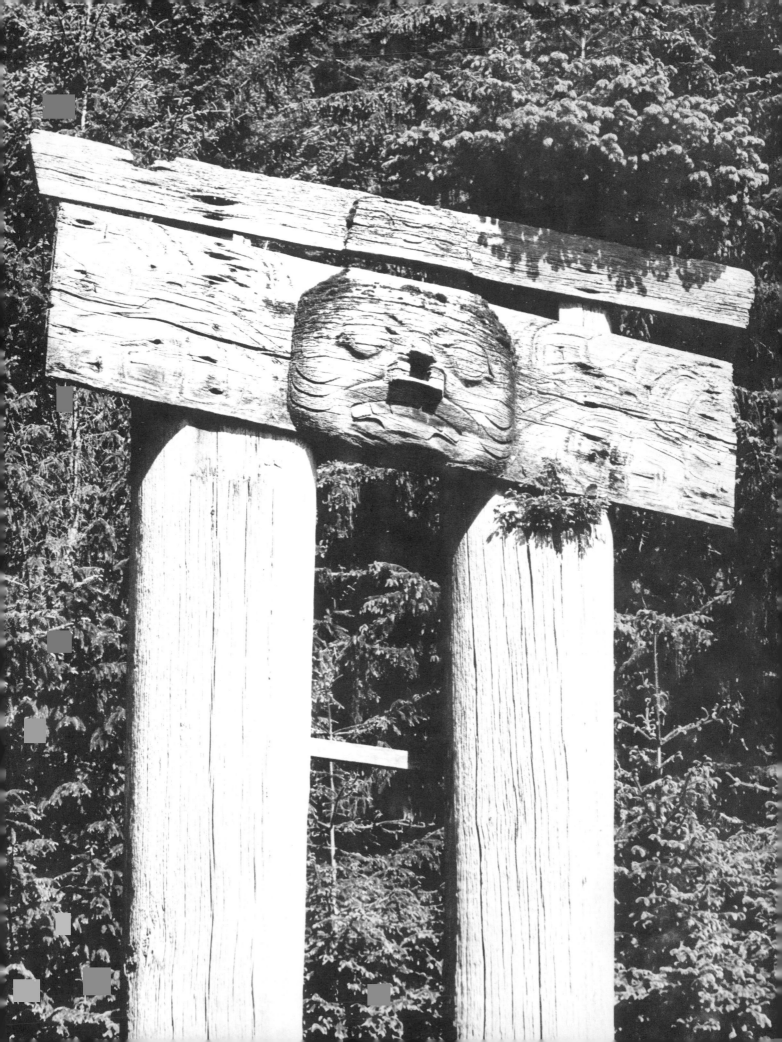

5c DOG-FISH DOUBLE MORTUARY

Also in front of "Eagle-Leg House" stood a double mortuary bearing the dog-fish symbol of the Eagle clan. The twin posts were each about eighteen feet high and supported a shelf about four feet from the top. On this, the coffin or grave-box rested. The top and back were planked in and a twelve-foot frontal board was nailed across the front to give the appearance of a box with a fitted top and bottom, identical in design to the smaller grave box within. This custom would suggest that at one time the grave boxes were simply elevated to the top of a post or tree and fastened there.

The dog-fish's head was of one piece with the frontal board carved in relief but hollowed out at the back to reduce weight and prevent cracking. The rest of the fish's body was represented in the frontal low-relief carving. The body is split in two to balance the design and shows a torso with two dorsal fins and a tail. The two pectoral fins are attached to the dog-fish's cheeks at the lower corner.

When the mortuary was examined in 1957, the downward curving mouth, rows of teeth, gill lines incised at the corners of the mouth, and the tapering forehead carrying two nostrils and two wrinkle lines identified the emblem as a dog-fish. A mortise where the nose should have been was puzzling. The puzzle was not really solved when the early photographs revealed a hawks beak had been attached to the face. This combination of hawk's beak and dog-fish head is not unknown. However, no explanation for it seems to be available.

In the winter of 1967-68 the mortuary board fell. In the spring it was photographed propped against the base of the mortuary posts. Later in the summer a party of Americans illegally removed it from the site, ostensibly to protect it from further damage by the weather. Fortunately, an alert R.C.M.P. constable spotted the board covered with a canvas on the deck of the "rescue" vessel, and those responsible for its removal were apprehended before the board found its way out of the country.

POLE 5C, HANCOCK 1967

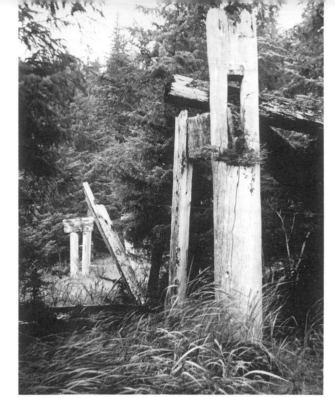

DUFF 1953

HANCOCK 1968

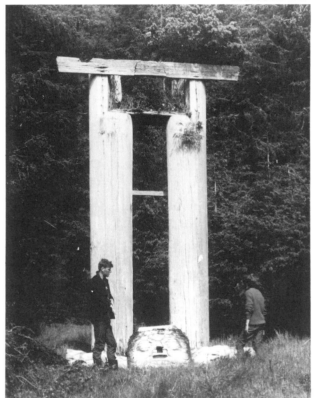

With the permission of the owners of the pole, the Skidegate Band Council, it has been lent to the Provincial Museum, Victoria where a Haida carver, Ron Wilson, has prepared a copy. Both original and replica will likely be returned to Skidegate for the benefit of the people there.

45

5d BEAVER MORTUARY

One of the most widely used of the Eagle clan crests was the beaver. It occurs eleven times on various poles in Skedans: seven times as a solitary figure and three times as the bottom figure on a pole. Only once, on Moon House Frontal 4a did it occur at the top and its position there raised some questions in our minds as to the accuracy of that model.

According to J.R. Swanton,[19] the beaver crest originated with the Tsimshian tribe of the mainland, and passed to the Haida through intermarriage. There are several quite different legends which relate how the crest came to be adopted.

The beaver also features in one of the many Raven stories. Here the beaver was in possession of the first salmon in the world after the great Flood and selfishly refused to share it with anyone. Raven, in one of his benign moods (for he was notoriously greedy himself), wished to share the salmon with everyone who might be as hungry as he. He turned himself into a handsome boy child to gain access to the beaver's lodge. The beaver's semi-human qualities apparently made him susceptible to the charm of young children. Eventually this particularly winning youngster stole the beaver's lodge, the salmon lake, and the salmon, and changing himself back into the Raven, flew away with all of them rolled up like a carpet in his beak.

The single mortuary shows a beaver's head. The crest indicated that the chief buried within belonged to the Eagle clan and the "hat" on the beaver's head indicated a chief of some importance. The actual property hat, worn by a chief on ceremonial occasions, was woven of spruce root and was painted with an elaborate design. Fastened to the crown of the hat were "rings", woven cylinders about two inches high, and the greater the number of rings on a chief's hat, the greater his wealth, prestige and importance.

The rounded nostrils, triangular-shaped mouth and two large incisors are the beaver's identifying characteristics.

When Dr. Newcombe visited the site in 1897, the box front was gone and was nowhere in evidence at the foot of the pole. The pole itself was so sound that it was still standing in 1968. One is tempted to think that this box-front may have been another that was "liberated" by a passing traveller, as long ago as 1890.

POLE 5D

BEAVER BRACELET

46

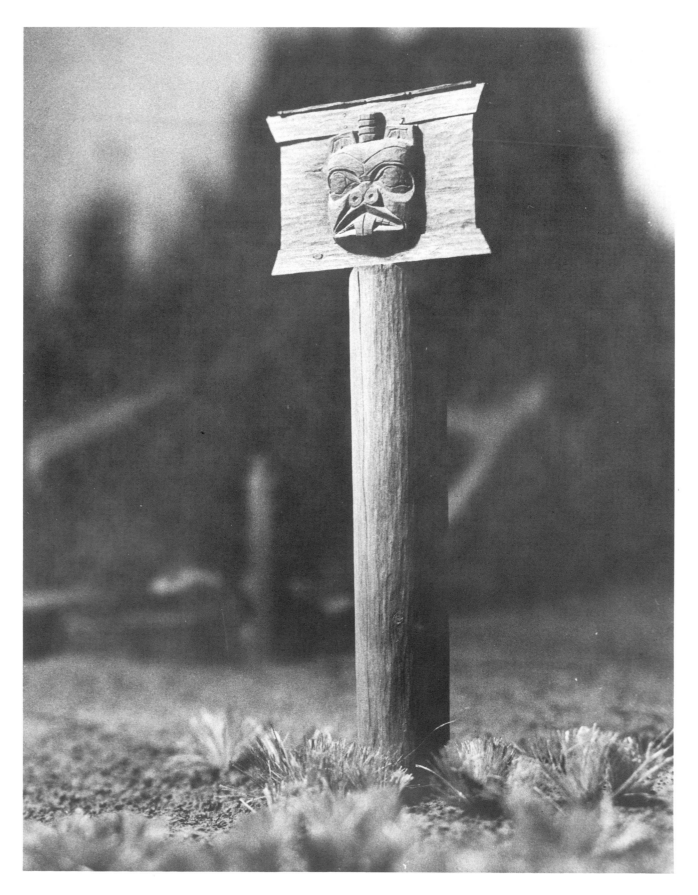

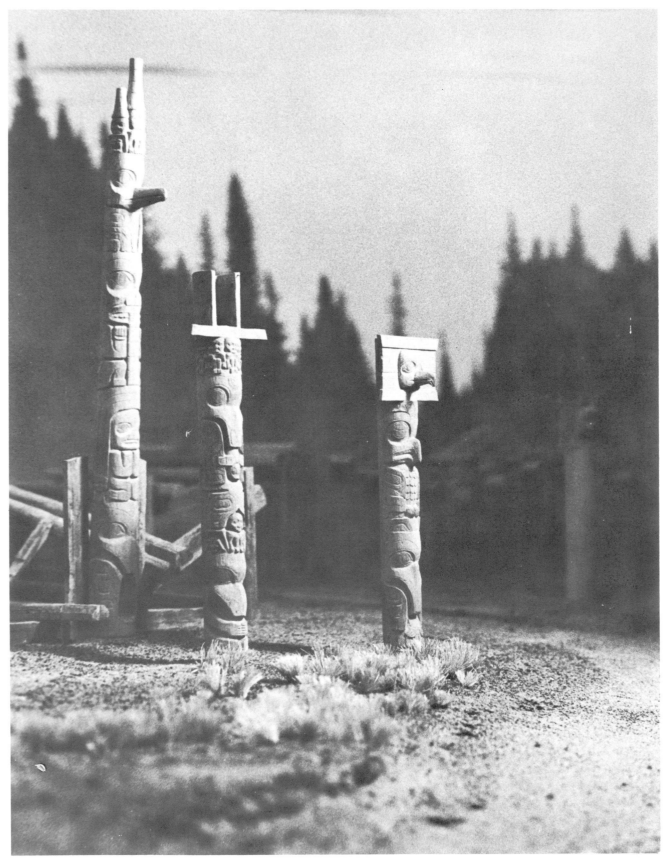

POLE 6A 6B 6C

6 HOUSE SIX

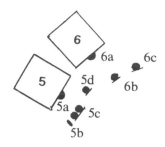

6a HOUSE FRONTAL

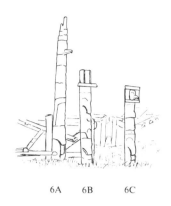

6A 6B 6C

The sixth house on Chief Skedans list belonged to an Eagle family from the clan called the "Djigua-Town-People." There is no record of the name of the house, but the house frontal pole stood against its front wall and the entrance to the house was cut through the base of the pole.

At the top of the pole sit the three little watchmen. The two side men sit with their hands cupped around their knees, seemingly prepared to wait out their vigil in relative comfort.

Just below the watchmen is the familiar eagle crest belonging to the house owner. The eagle's wings, very short in comparison to the head, are folded forward. The wing joint is indicated by the double incised "egg" design or ovoid at the shoulder. The bird's talons appear in the ear spaces of the figure below.

The second large crest figure, under the eagle has given us some difficulty, as it has never to our knowledge been positively identified. Basically it appears to be a land animal of some kind, a bear or a wolf, holding before him a ringed cylinder resembling a property-hat. By comparing this figure with others, we have concluded that this crest is probably intended to represent the Tca-maos, or Underwater Snag, a prized Raven crest. This mythical creature appears in various forms, but primarily it represented the Indians' healthy respect for submerged driftwood snags which were, and still are, responsible for the death of many an unsuspecting canoeist. The legends represent the snag as a piece of driftwood rising from the back of a sea-grizzly bear.

Graphically this combination of fearful identities could be shown in a number of ways, but always with the two ideas of bear and wood stick conjoined. Here the stick seems to be displayed in front of the bear in the manner of a tail turned up in front, but it can also be shown rising out of the bear's head, or represented by another semi-human figure, which is the snag personified, sitting on top of the bear's head. (Compare this figure with pole 14a page 78).

Just below the Tca-Maos is another well-known Raven crest appearing twice in Skedans, the Rainbow. According to Haida legend,[20] the figure with the odd flipper-like hands and feet was once a human being, until his magical transformation into a being called "Supernatural One Upon Whom It Thunders." Thereafter he appeared to mankind as the Rainbow, which is his "dressing up", a term suggesting a garment of many colours put on for special occasions. On the pole the bands of the rainbow arch over the head of Supernatural One and terminate in little human faces and hands which one might imagine to be puffs of cloud, or raindrops.

At the bottom of the pole is a second Eagle crest, the black whale, whose pectoral fins frame the entrance doorway. His flukes are hidden in the grass at the base of the pole. This whale, and the eagle at the top were the crests of the house owner. The two central crests, the Snag and the Rainbow, were Raven crests most likely those of the house owner's wife.

Approximately forty feet high originally, this pole was removed to Prince Rupert in 1935 and stood outside for many years. Efforts were made to keep the wood in good condition but this is by no means a simple task, and finally, concern for its deterioration caused it to be transported to the Provincial Museum in Victoria where it could be stored in a controlled atmosphere.

6b BEARS AND KILLER-WHALE MORTUARY

The bears and killer-whale mortuary had fallen when the site was visited in 1957, but it had begun to disintegrate long before. The frontal board with its grizzly bear crest, had dropped off as early as 1901 and is shown in photos of that date leaning against the base of another pole. It was subsequently collected by Dr. C.F. Newcombe and sent to the Field Columbian Museum, Chicago, which has many other equally fine pieces of Haida art including a mortuary board, also from Skedans, almost the twin of this frontal. On either side of the bear's head, an elaborate design incorporating features of the bear's body was carved in low relief and painted.

Immediately under the mortuary box, almost as though they were supporting the box on their heads, crouch five human figures. They may have been relatives of the deceased.

The rest of the support post was carved with two major crest figures; the killer-whale, full-length, and the grizzly bear kneeling at the bottom. As a mortuary should carry the crests of the person interred within and have either all Raven crests or all Eagle crests, we must assume that this whale is a killer-whale to match the other two Raven crests on the pole. It should have had somewhere about it a dorsal fin, perforated with a round hole to distinguish it from the Eagle crest baleen whale. It is possible that this fin was originally nailed onto the top of the mortuary box, one such fin appears on a mortuary box in Skidegate. It is also possible that the Haida artist decided to forego this convention and indicate the killer-whale by another device. The whale is shown with a smaller whale in its mouth. Killer-whales have been known to attack and kill baleen whales which only eat plankton. Knowing that this crest figure should be a killer-whale we can assume the artist intended the small whale held in the mouth as an indicator that the large whale was a killer-whale, even though the usual perforated fin was not apparent.

The bottom figure was that of another bear but

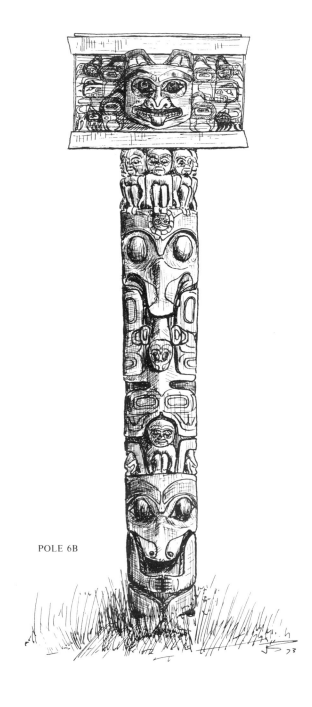

POLE 6B

when the pole was photographed in 1901, a shrub had sprouted between the bear's knees and hid the lower portion. He may have been holding something in his paws at one time. Toads were shown coming out of the bear's ears and may have recalled the Haida legend related on page 65. Between the bear's ears sat a human figure, perhaps the chief himself.

50

6c EAGLE, HAWK AND CORMORANT MORTUARY

The three figures on this Eagle family mortuary are particularly interesting because they all represent bird crests: the eagle, the hawk, and the cormorant. In each case, the Haida artist has included both traditional and realistic features in the ingenious blend so typical of this inventive people.

The eagle on the mortuary front has the usual human eyes and eyebrows of the traditional crest figure. Only the beak, a separate piece mortised into the face, identifies this bird now, although there once may have been a supplementary painted design of wings and talons filling the rest of the space. The straight beak, turned down just at the tip, however, is sufficient to mark the eagle.

The second bird, just under the panel, has the curious half-moon eyes of the Haida hawk. The hawk is a crest to both Eagles and Ravens and when shown in conjunction with a whale, represents the Raven crest, Thunderbird. Here, however, the hawk is an Eagle crest on an Eagle mortuary, the only hawk portrayed in Skedans in this form. He has a short, blunt beak, with a hook back at the tip. Feathers sprout vertically between his eyes and are arranged in rows across his breast. He has been provided with a pair of short wings, a pair of talons, and a pair of human legs with feathered shins which must have proved awkward in flight. On the pole the legs look natural enough, and are intended to suggest human origins. The hawk, like the Supernatural One of the rainbow crest, was said to have been a man initially, before his magical transformation.

The bottom figure is that of the cormorant, also an Eagle clan crest. Its long-beaked face resembles the Raven, but there are none of the other semi-human indicators of that bird here: only a very proper pair of wings folded down, a pair of talons and a row of tail feathers circling the base of the pole.

These three birds make a strange flock, but they outline the family ties of the Eagle chief interred within. The pole fell some time ago. POLE 6C

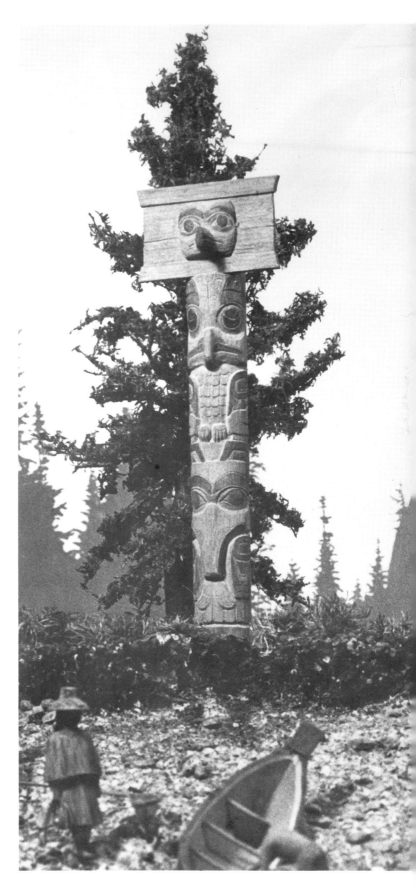

51

7 HOUSE NEAR THE BEACH

Two houses at Skedans were built each in a corner of the U-shaped bay, where the right-angle turn of the main row of houses left just enough room for another structure in the corner. Both houses were derelict in Dawson's time which may only be coincidence, although they may have been built too close to the beach to withstand storms of unusual strength.

While trying to name the houses by matching the photographs against Chief Skedans' list, it became apparent that the two 'corner' houses were going to prove troublesome. There was no way of knowing at what point in the list Chief Skedans had dropped out of the main line sequence to pick up the house in front. At the western bend, for example, house number seven (which is unnamed), house number eight ("Black Whale-House"), house number nine ("Eagle House"), and house number ten ("Peaceful House") are all gathered in the corner with no clues to link name with picture.

We have assumed that Chief Skedans listed the beach house as seventh, before dropping back to list those which formed a straight row behind. House number seven, therefore, which had no name that Chief Skedans could recall, we have dubbed "House Near The Beach." It had belonged to an Eagle family from the "Djigua-Town-People."

Only the skeletal framework remained in 1878 but its foreground position ensured that it was well photographed. With the roof gone and the wall-boards taken away, no doubt to be re-used, it provides a particularly interesting view of the interior of a six-beam dwelling. Few such views

exist. Big-houses had no windows in the early days and the only light came from the fire in the center of the floor, or daylight from between the wall-boards and from the smoke-hole in the roof. Without flash equipment or a great hole in the wall, interior photographs would have been impossible.

In this instance, however, besides the usual house frontal pole (opposite), the photographer was able to record an inside housepost in its original position (7b Page 54), and an inside horizontal memorial (7c page 55) which has long since gone to a new home in the American Museum of Natural History.

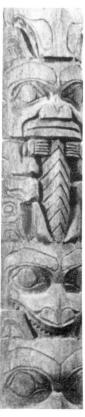

POLE 7 A

SCULPIN CREST

7a HOUSE FRONTAL

The "House on the Beach" had one of the tallest and most elaborately carved poles in Skedans. It is unusual because it appears to carry only Eagle crest figures; the eagle, sculpin, cormorant and beaver. Usually the house frontal poles carry the crests of both the husband and the wife, and are therefore a mixture of Eagle and Raven crests.

Under the guardian watch of the three sentries at the top of the pole is the important eagle crest, holding in his talons the upside down head of a spirit figure. The eagle seems to be linked with the sea-creature just below whose broad snout and upswept pectoral fins resemble the ordinary whale. In a story recorded by James Deans,[21] a young man was driven away from his own home and married into a tribe of supernatural Eagles. He was able to become one of them by donning a suit of feathers with which he could fly. He became very fond of going out in his "suit" to hunt for whales, but one day he was captured by a sea-creature named Ah-seeak, with a head resembling that of a seal. This creature caught the young man and pulled him beneath the sea leaving only his upflung arm showing above the surface. One of the other eagles of the village, seeing the arm, took hold of it to pull him out but was in turn pulled under except for an arm. Before long, the entire village was strung out in this manner until the old Queen of the Eagles managed to break the spell and release them.

The next group under the head of Ah-Seeak (if that is what it is), shows a semi-human figure with animal ears clutching the spiny backbone of the sculpin which hangs head down. The sculpin is a "bullhead" type of fish symbolized by a joined dorsal fin and two projections, like feelers, which are shown, sometimes over its mouth, sometimes over its eyes, like horns. This placement of the feelers has sometimes caused the sculpin to be wrongly identified as a mountain goat. Further proof that a fish was intended is afforded in this particular example by the two pectoral fins which flank the spiny backbone and fold upwards along the sides of the pole.

The man-like creature holding the sculpin may represent a man in the legends who was turned

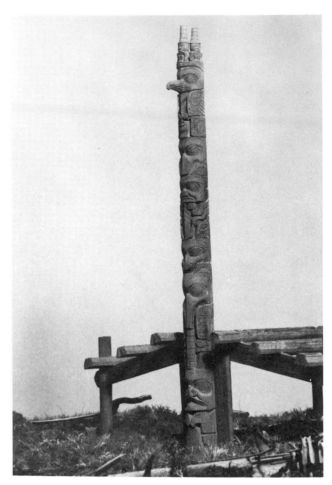

POLE 7A

into a monster and was fated to catch only sculpins for his food; not, apparently, a fate to be desired.

The next figure down is that of a bird, whose talons hang below his wing-tips. Once again it is probably the cormorant, although other birds, particularly the raven, are possible.

The bottom figure of the house frontal is a fine example of the beaver crest of the Eagle clans. His cross-hatched tail, representing the scaly tail of the living animal, is turned up in front of his stomach. His rounded nostrils, triangular mouth and prominent front teeth mark him immediately. He is wearing a property-hat of six cylinders.

The house frontal fell several years ago and its carcass still rots on the site, the upper portion hanging out over the steep incline of the beach.

7b INSIDE HOUSE POST

An inside house post was a carved column standing flush with the inside back wall and facing into the center of the big-house. It often gave the appearance of supporting the roof timbers or cross-beams, but it actually had no structural function, at least in Haida houses. In front of the pole was placed the chief's bench or chair and this group formed the center of attention during festivities.

Dr. Newcombe recorded only three inside house-posts for Skedans in 1897, two of which were later removed to American museums but this one remained at the site, fell and split in two. It stood at the back of the "House Near the Beach" at the western bend of the bay. Between the eagle at the top and the whale at the bottom, a human head appeared, wearing a tall property-hat and was likely a portrait of the chief who owned the house.

In a drawing or photograph, these inside poles look small and insignificant, but it is to be remembered that they stood at least twelve feet high, each major figure as tall as a man. The play of light and shadow across their features in the darkened house must have been one of the first sights of the world known to Indian infants, becoming an integral part of their experience. The house post, even more than the house frontal, must have been a treasured family possession.

POLE 7B

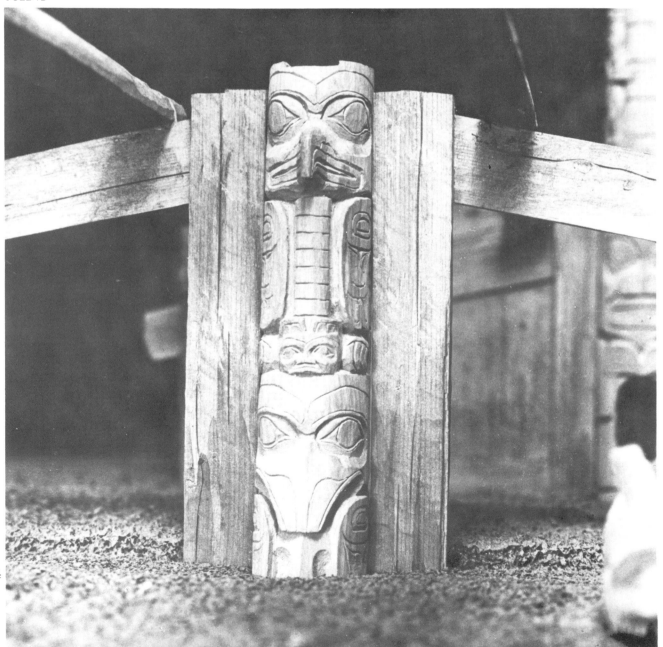

7c BEAVER HORIZONTAL MEMORIAL

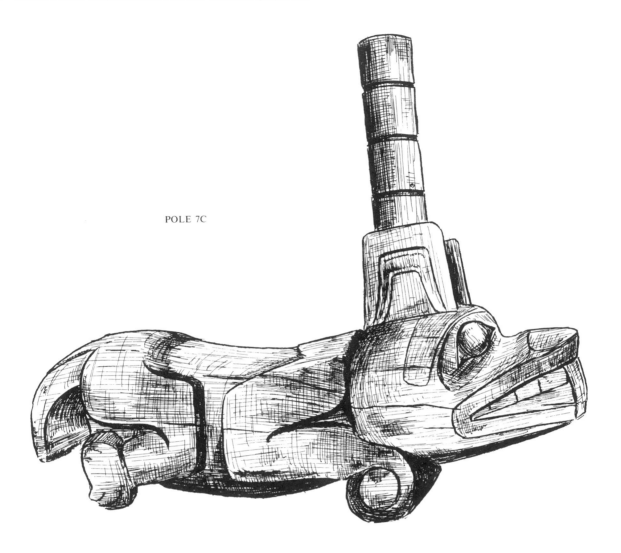

POLE 7C

Dr. Newcombe's photograph of 1901 shows this horizontal memorial inside the framework of the "House Near the Beach." It was near the back of the house, a position of honour, and while it may have taken some part in ceremonials, it may also have been a memorial to a departed chief.

Dr. Newcombe listed this memorial in his 1897 notes,[22] adding a postscript "at New York, 1901" when he had it removed from the site and shipped it to the American Museum of Natural History. By so doing, he saved it from almost certain destruction, for large though it was, it was one of the most easily removed of the totemic figures and no doubt would have dis-

appeared. Those figures now in museums will last a good many years more than those left on the site which have deteriorated beyond recognition.

The figure is that of a crouching beaver, wearing a property hat of four cylinders. The forepaws clutch a gnawing stick, the tail hangs down and was presumably cross-hatched, though it doesn't show in the photograph. The elongated front teeth complete its identity.

Between ten and twelve feet long, it was carved from a log at least thirty inches in diameter. The ears and hat were separate pieces mortised into the head.

8 BLACK WHALE HOUSE

8a HOUSE FRONTAL

The eighth house in Skedans was known as "Black Whale House" and belonged to the Eagle family from the clan "Those-Born-at-Skedans." The house stood across a small creek from the sixth house but was set further back and was the first of a row of fourteen houses lining the back of the bay. Most of the early photographers, unable to photograph the village from above or from out in the bay to get a frontal view, resorted to shooting down the line of houses and poles. The subsequent foreshortening of distances and the distortion of sizes and relationships has played havoc with our attempts to make an accurate record of the poles.

For example the house frontal of the eighth house was almost identical to that of the sixth house, but stood at an angle to it perhaps 70 feet away, and the two never seemed to appear in one photograph. For a long time we thought them to be the same pole, but a pole with an uncanny ability to move itself forward and back, left and right, behind and in front, in a kind of stately foxtrot from one picture to the next. About the time we began to suspect shamancraft, we noticed that one top eagle had a long beak, the other a short stubby beak. All the watchmen wore property-hats, but the central watchman in pole 8a had a set of animal ears as well. The only other noticeable variation was the number of incised rings on the cylinder held by the second figure. We were relieved that the solution to the mystery simply involved adding another pole to the total.

As before, the top eagle and the bottom whale were Eagle crests, and the house presumably took its name from the bottom figure surrounding the door. The two central figures, the Tca-Maos (if that identification is correct) and the

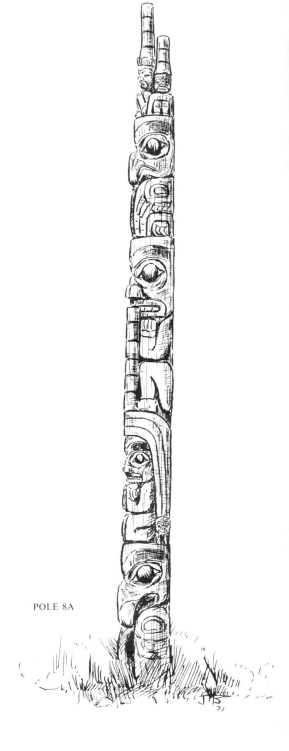

POLE 8A

Rainbow, are Raven crests, probably belonging to the owner's wife.

This pole appears in Dr. Newcombe's notes of 1897 where it is sketched leaning forward, and it shows up in several photos taken between 1901 and 1915, still leaning. It subsequently disappeared.

8b GRIZZLY BEAR MORTUARY

In front of the second "Rainbow" house frontal but much closer to the beach, stood this eighteen foot mortuary. It illustrates, in abbreviated form, one of the most commonly used totemic figures, the grizzly bear, a crest of the Raven clan. There were at least twenty of these crests at Skedans, giving rise to one of the names of the village, Grizzly-Bear-Town.

The circular eyes and nostrils, the wide up-turned mouth and protruding tongue are the classic symbols of the Haida bear. There is a beautifully carved wooden rattle in the British Museum collection in England, rated as one of the finest pieces ever of so-called "primitive" art, which is identical to the bear on this pole and might well have come from the hand of the same carver.

The ears on the mortuary box were separate pieces which jutted forward sharply, giving the bear an alert, questioning look. The paws and claws were shown incised at either side of the chin. The upper half of the supporting column was fluted in long vertical lines, a method of decoration which occurs several times on Skedans poles but is not common elsewhere.

Dr. Newcombe sketched this pole in 1897 but it has since disappeared.

POLE 8B

POLES 5B 5C 4B 6C 6B 6A 8B

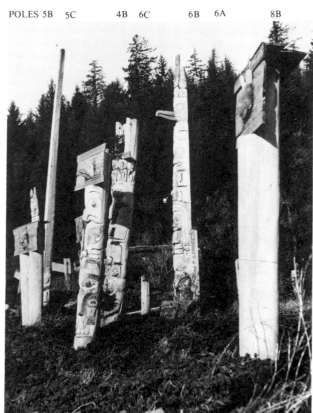

9 EAGLE HOUSE

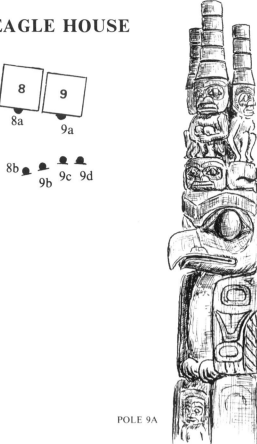

POLE 9A

9a HOUSE FRONTAL

The ninth house in Skedans was known as "Eagle House" and also belonged to a family from the Eagle clan, "Those-Born-at-Koona." The house was located to the west and north of the "House Near the Beach," and consequently is hidden by the latter in every early photograph. Only the three watchmen and the eagle crest at the top can be seen over the foreground house and poles at the extreme left edge of Dawson's general view of 1878. The pole and house may have been old even then, or subsequently destroyed by fire. By Newcombe's visit of 1897 they had vanished.

The central watchman on this pole sits holding onto his knees. Below him appears a peculiar human figure whose details are too indistinct to reproduce with any degree of certainty. Beneath him is the usual large representation of the eagle crest. Unless another early photograph is discovered, the rest of this pole may never be known.

9b EAGLE AND CHIEF MORTUARY

This pole was one of two in Skedans which almost escaped the early photographers altogether. It appears at the far end of a long line of poles in Dawson's photo of 1878, and even in a full-plate print, it stands only one-quarter of an inch high. Newcombe makes no mention of it in his notes and no closer photograph has come to our rescue. Even with the aid of a strong magnifying lens, only a general idea of the figures on this pole can be suggested and these may have to be altered very considerably if further evidence ever appears.

The mortuary box front had no carving on it but faint lines appear suggesting a low relief or painted design had been its ornament.

Directly under the box were the head, arms and legs of some small animal — a frog or a bear cub possibly, perched on the head of the large figure underneath. We think the larger crest figure to be an eagle, with its beak fallen off and the mortise hole appearing in the place of the nose as shown on the model pole photograph.

A smaller human figure appears squatting in front, and over his head an arched band, which may have been only the uncarved chest of the larger figure.

Next down was a "spirit" figure, head and arms, rather larger than is usual for such figures on the poles. The bottom figure was also human with his hands held up to his chest where he held an animal or object which just cannot be made out, but which resembles the long narrow body of a weasel or a land otter. This carving may represent the chief holding his main crest figure.

None of these figures resembles other mortuary crests as represented on the Skedans poles and must not be taken as a definite likeness. We felt that including our impression of what the figures appear to be might result in the discovery or identification of a closer photograph by another early visitor to the site.

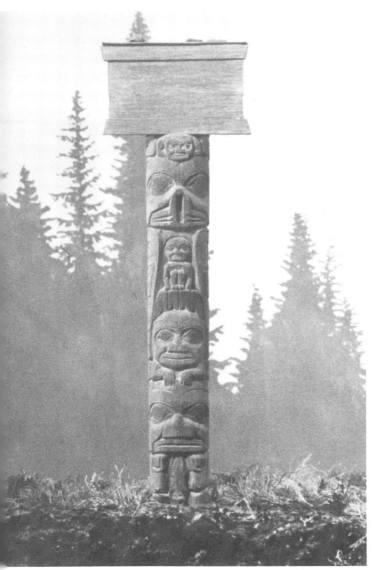

POLE 9 B

PARTIALLY MADE CEDAR CANOE

DESIGN FROM FROG BRACELET

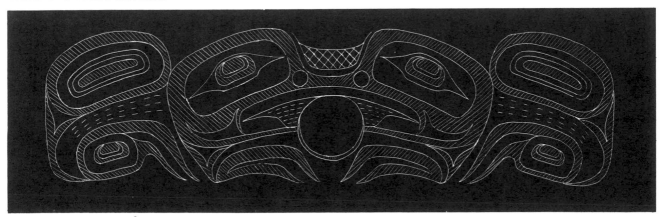

9c WHALE MORTUARY

This mortuary was partly hidden by a house beam in Dawson's photo and no other photograph has come to light which revealed its features completely. It is out of sight in the Newcombe photos and the pole had disappeared between Newcombe's visits and the time when Emily Carr photographed this section of the village.

The box front can be seen, and some slight figuring suggests a painting or low-relief carving, the details of which cannot be made out. Just below the box can be seen a little figure who seems to have got down on his hands and knees to peer through a hole represented by a double line encircling his face. If we can assume for a moment that the crest figure below is a whale, then we see it may be the whale's blowhole through which the man is peering. Perhaps the face in the whale's blowhole, a common convention on Haida poles, is intended to represent someone on the inside, like Jonah, trying to get out. There are several legends to support such an assumption.

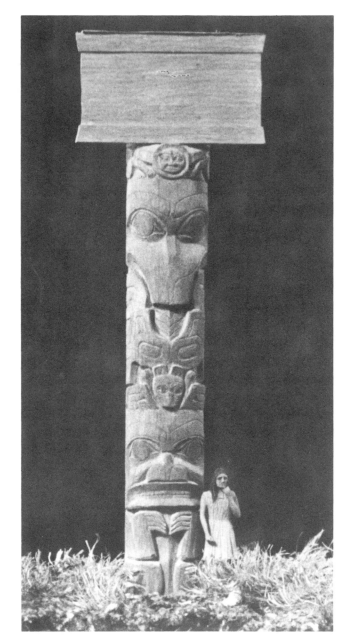

POLE 9C

HAIDA EYE

The crest figure is strongly carved with large eyes and a prominent snout. Just above the obstructing beam can be seen two diagonal lines strongly suggesting the flukes of the whale turned up in front of his body. We were surprised, therefore, to find that Dr. Newcombe had written the word "bear" adjacent to this figure in his scribbled sketch, and unfortunately he did not include the lower figure at all. Just possibly the figure could be a bear, with paws held up to his chest. The absence of rounded nostrils and protruding tongue, and the presence of the double circle suggesting a blow-hole, how-ever, have led us to represent this figure as a whale.

Then the house beam intervenes hiding the lower part of the whale and the upper half of the next figure right down to its toothy grin. The hands and feet, and the lower part of the face, appear below the beam. Because of the strong resemblance between the lower part of this crest and another figure appearing on house frontal pole 13a we have re-drawn that figure here as well. Without the top half of the face, it is useless to attempt an identification of the figure, except to suggest it was probably a land animal.

9d HAWK MORTUARY

The twenty-foot mortuary was one of several in Skedans which had the upper half of the support column fluted instead of carved or left plain. The post was still standing in 1957, but like all the others, the box front was gone. It appears in photographs as late as the 1920's.

The central face was that of the hawk whose prominent beak turned back upon itself to touch the semi-human mouth. The frontal board had been painted with a supplementary design of the wings of the bird. Because of the similarity between this hawk and that depicted in pole 12c, which was a Raven mortuary, we have assumed this mortuary to be a Raven memorial as well, even though it stood among the cluster of Eagle houses.

POLE 9D

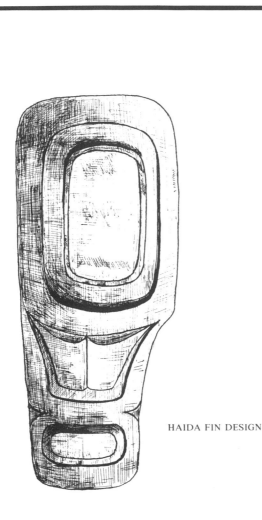

HAIDA FIN DESIGN

10 PEACEFUL HOUSE

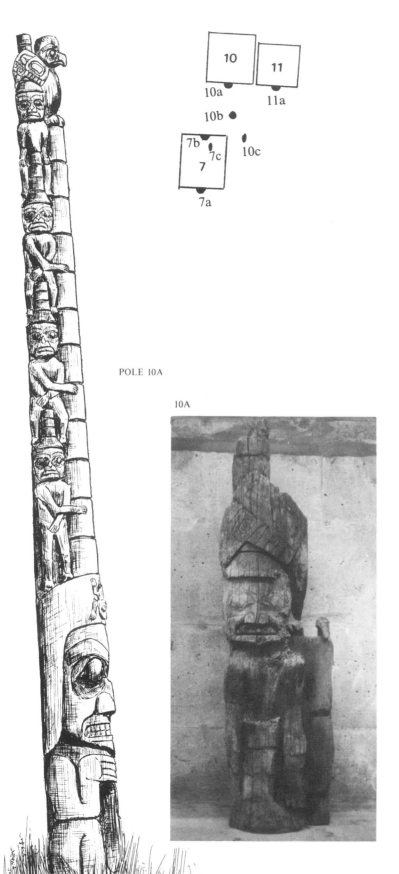

POLE 10A

10A

When the world was young, Raven travelled the skies performing deeds of good and evil. In one of his more spiteful moods, he quarrelled with a great chief called Qingi and to punish the chief he brought down a terrible flood upon Qingi's village. The chief had supernatural powers of his own, however, and as his people scrambled to escape the flood waters, he caused his segmented dance hat to grow higher and higher. The villagers were able to climb the hat and escape drowning.

This legend is illustrated on the house frontal pole of "Peaceful House," the tenth house in Skedans, whose family was apparently not known to Chief Skedans in 1900 and so has not been recorded. The large figure at the bottom is the chief, Qingi, supporting his dance hat upon which climb the villagers — eight altogether. At the top is an eagle, whose outstretched wings fold back over the hats of the uppermost figures. He seems too small to be a crest figure and may be intended to represent the eagle of the legends who was at times Raven's friend and at other times his enemy. Here he seems to be helping protect the villagers.

Nearly identical poles existed at Tanu, Masset and Skidegate, each belonging to an Eagle chief. The Qingi hat crest was the prerogative of the Eagles. The chief who erected this pole in Skedans must have been dead for a long time or distinctly out of favour for Chief Skedans not to have remembered anything about him. It would be safe to assume then, that the house was an Eagle one, making a total of seven Eagle houses in the village.

The pole had fallen face down and was badly decayed by 1954 when the official salvage party visited the site. Even so, the same persons who illegally removed the dogfish mortuary board 5c apparently felt that parts of this pole were still worth taking and allowed themselves the liberty of cutting the top of the pole away from the disintegrating remainder. Broken into three pieces, the eagle and the two villagers have joined the collection of the Provincial Museum, whence they were sent after being confiscated.

10b BEAVER MEMORIAL

POLE 10B

Between the tenth and the eleventh houses stood a memorial pole which appears in the photographs but seems to have disappeared entirely from the site. At the bottom squatted an enormous beaver, nearly ten feet high, the upper part of the pole being divided into eleven cylinders of property-hat for a total height of about thirty-six feet.

The cross-hatched tail, the feet and the haunches of the beaver are assumed to be there. They are hidden in the grass in the 1878 photo. The gnawing stick can be seen, held against the beaver's chest by his forepaws. The triangular mouth frames the very obvious incisors; the rounded nostrils, heavy eyebrows and animal ears are the same as in the other beaver figures in Skedans. This time, however, the artist filled in the ear spaces with little toads, shown as though they were crawling out from inside the beaver's head.

Below the gnawing stick, a small bird's head can be seen but the details surrounding the head are too indistinct to be drawn sharply. It most nearly resembles a small eagle with talons hanging down and wings held up in an arc over the head. An almost identical figure on one of Swanton's model poles was identified at the time as the hummingbird,[24] a crest of the Eagle clan, which should presumably appear on poles but which is very difficult to pick out.

The beaver, toad and hummingbird are all crests of the Eagle clan, and grouped together in this fashion might serve to identify the person to whom the memorial was raised.

10B

63

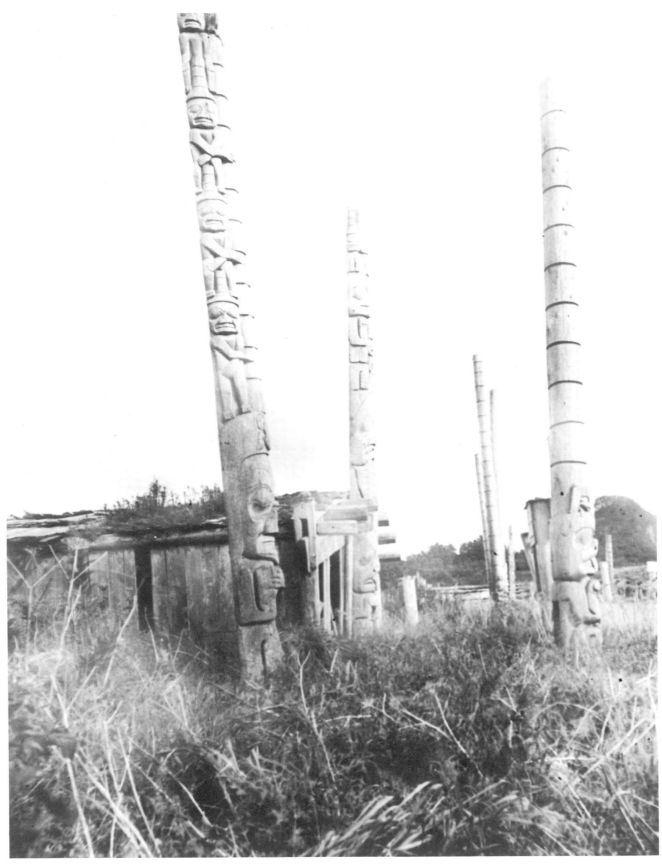

10c TOAD HORIZONTAL MEMORIAL

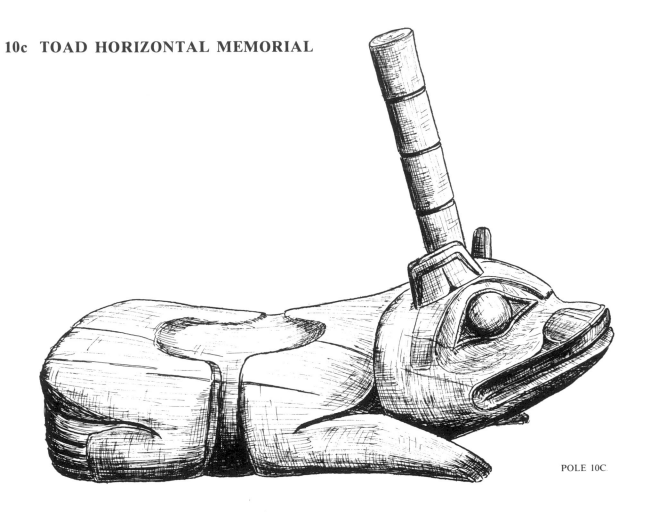

POLE 10C

This horizontal memorial appeared in front of the beaver memorial. It was about ten feet long and thirty inches high. The separate ears and property stick were mortised into the head. It was an Eagle crest and might have been a memorial to an Eagle chief.

Toads are not usually shown with ears, but the wide toothless mouth, flippered back feet and lack of tail serve to confirm its identity. It was collected from the site by Dr. C.F. Newcombe just after the turn of the century and was shipped to the Field Museum in Chicago.

Toads and frogs quite often occur in the legends and in fact seem to be a popular theme in folk tales the world over. A frog led Raven to adventures beneath the sea, and ravens were supposed to eat toads or frogs. The Volcano Woman, whose frog-son was destroyed by thoughtless youths, is often shown with frogs on her hat and on her cane.

The only truly Haida legend concerning frogs however, purports to tell why there were no such creatures on the Queen Charlotte Islands. (There are toads on the Islands, apparently, but no frogs.) At one time, according to the legend,[25] frogs were also plentiful in Haida land. One rugged individual, hopping down a forest trail, chanced to meet a bear, who naturally enough, put the little animal into his mouth to find whether it was good to eat. Finding it was not to his liking, he spat it out, "Pugh!" The frog, whose life had thus been spared, returned to his fellows and described his adventure, withholding no horrifying detail. His description so terrified his companions that they resolved to leave the area at once and never return. From that day to this, so it was said, frogs have never again been seen on the Queen Charlotte Islands.

Why they have not similarly deserted the mainland has not been explained.

65

11 STANDING HOUSE

11a HOUSE FRONTAL

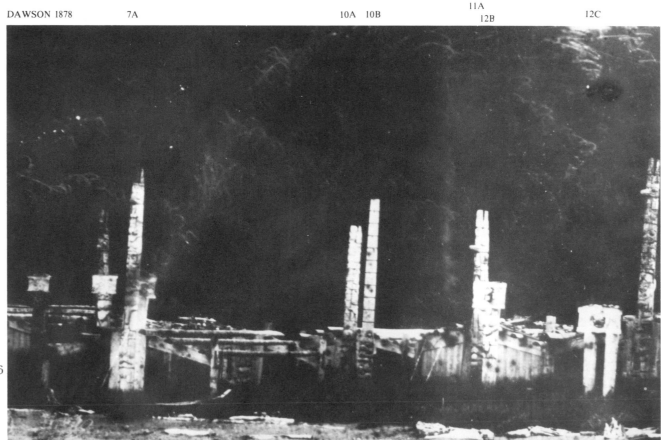

The eleventh house in Skedans was called "Standing House" and was the last of the Eagle family houses. Both Dawson and Newcombe photographed the house frontal pole, but no trace of it can now be found. It stood about 36 feet high and was one of the older type with the doorway cut through the bottom figure. Such a large hole, of course, would weaken the pole's structure and provide more surfaces open to damp rot and wood bugs. Not many of the older type poles have survived.

Despite the fact that this is an Eagle family pole, and that most of the house frontals up to this point in the village have had eagles as the topmost crest, we feel that the top bird represented here is the raven. Confusingly enough the raven was a valued crest of the Eagle clan.[26] It was also a crest of the Raven clan, but there it was not highly prized. The Indians in Swanton's time could give him no explanation as to how this had come about.

Unlike the eagle, however, this figure has a long straight beak coming to a point at the end, the beak being a separate piece mortised on. Instead of wings, the raven has human arms with feathered elbows and human legs. It is associated with a human figure wearing a property-hat which was probably intended to represent a chief.

The second figure down is a very satisfying representation of the dog-fish whose domed "forehead" and down-turned mouth carrying a fearsome set of sharp teeth, are his most noticeable characteristics. His pectoral fins are folded under his chin (if a dogfish can be said to have a chin) and his tail, split in half, is shown on either side of the pole underneath the pectoral fins.

At the base of the pole was the third Eagle crest, another beaver. Here, as with most of the beavers at Skedans, he wears a property-hat of several cylinders and carries a gnawing stick between his forepaws.

DAWSON 1878 7A 10A 10B 11A 12C
 12B

66

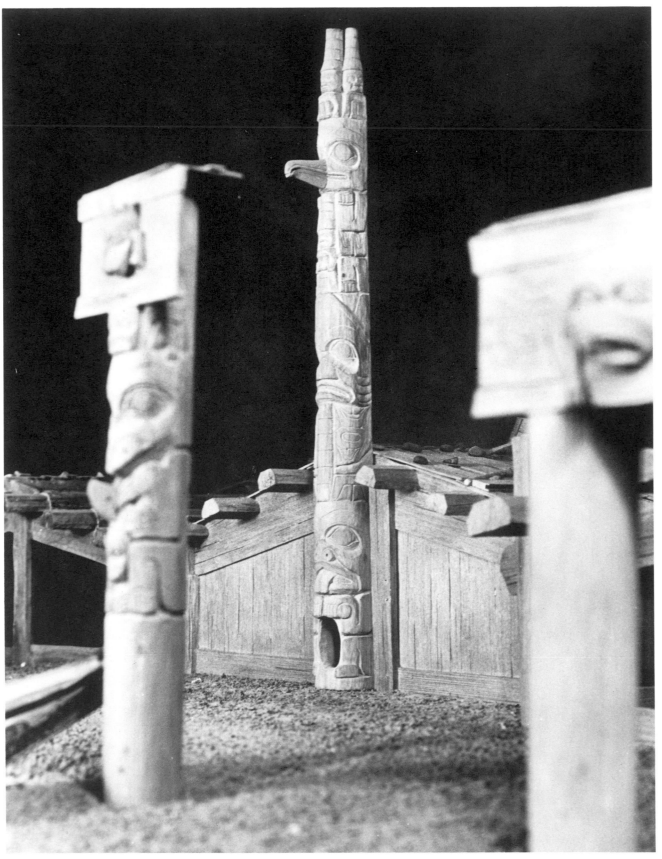

POLES 12B 11A 12C

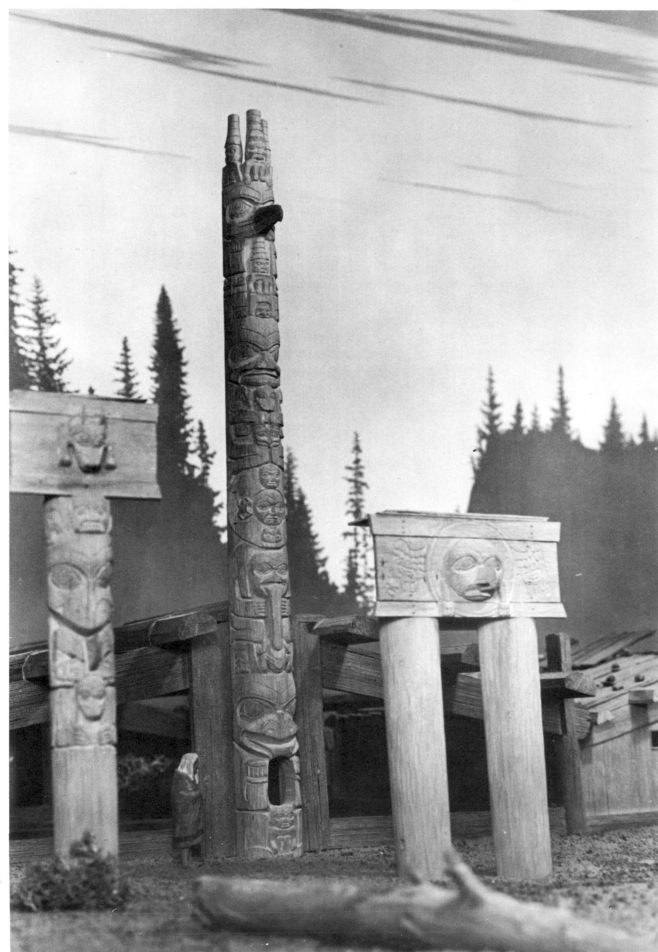

12 CLOUDS SOUND AGAINST IT (AS THEY PASS OVER)

Grave House

11 12 13

11a 12a 13a

12b 12c 13b 13d

13c

12a HOUSE FRONTAL

At the heart of Skedans, in the center of the main row of houses, stood the town chief's house. This Raven House was by far the largest of the houses, over fifty feet square, and the floor descended in a series of steps or platforms within making the house even larger than it appeared from the outside. This magnificent structure was "Clouds Sound Against It (As They Pass Over)."

The house frontal pole was not only one of the tallest in the village but was also the most intricately designed and carved. At least twenty creatures large and small were worked into the design. Unfortunately, none of the early visitors to the site obtained an explanation for the figures, as far as we know, and we cannot hope to do justice to the complicated ideograms without such a record.

The topmost crest is, once again, the raven, with a straight beak about two and a half feet long mortised on. As in the preceding house frontal, the raven has human arms with feathered elbows and human legs and feet. Here too, he is associated with a little "chief" wearing a property hat. The tiny bird face below the chief might either be the butterfly, who was Raven's companion in some of the Raven legends, or the elusive hummingbird crest.

The second figure down is that of a human being holding a sea-creature whose turned up tail is decorated with the face of a bird. The presence of stylized feathers on the elbows of the human would suggest that this might be Raven in human form together with other figures from the Raven legends.

The third major figure from the top was the moon crest, the exclusive property of the Raven chiefs. In order to make the moon as large as possible, it was designed to be of greater diameter than the width of the pole and two extra pieces were stapled to the outside edge to complete the circle. Hand wrought iron staples about three inches long were used. Little faces appear above and below the large central face, but we could not make out what the two small side carvings within the circle represented.

The arms of the "man" in the moon appear below the circle, and hold an extremely peculiar little figure with an enormous top lip which drops down onto the back of a frog. As Raven is the creature most commonly associated with frogs, we are tempted to think this may be Raven once again in human form — human except for his beak, that is — and Raven in conjunction with the moon can only be intended to recall the legend of how Raven brought light into the night world.

The tale relates how Raven, through magic, was born to the daughter of the great chief who possessed the moon and stars which he kept locked up in a box. In his disguise of a tiny human infant, Raven cried and cried, until his "Grandfather" gave him the glowing ball of light to play with. Changing immediately into the sooty raven once more, he flew away through the smokehole carrying the moon in his beak and placed it in the sky for all men to enjoy. Raven is often shown with the moon in his beak, but it is uncommon to see the moon holding onto Raven, astride his shoulders as though riding on his back.

The bottom figure is that of the grizzly bear, the most common of Raven clan crests. He too is shown with figures coming out of his ears and another human figure at his feet, partly hidden by the grass. Some idea of the size of this pole may be had by realizing that the door-hole through the bear's body was four feet from the ground.

No trace of this pole remains at the village. It had disappeared sometime before the 1920's.

12b MOUNTAIN GOAT, SEA-BEAR AND COPPER MORTUARY

The greatest enemy of the totem poles is the climate, which both encourages rot in the old wood, and stimulates the rapid growth of new wood. Many of the photos taken after Skedans was deserted show trees and brush bursting out of the tops of the mortuaries where the hollowed cavity held water like a cup, and the bones of the dead provided a fertile humus.

This mortuary has been destroyed in this manner. A seedling, sprouting in the mortuary cavity, put down roots clear through the rotting pole to the ground. When the pole split under the pressure of growing roots, the upper portion together with the tree grown to thirty feet, fell backwards. Only the lower front portion of the

POLE 12B

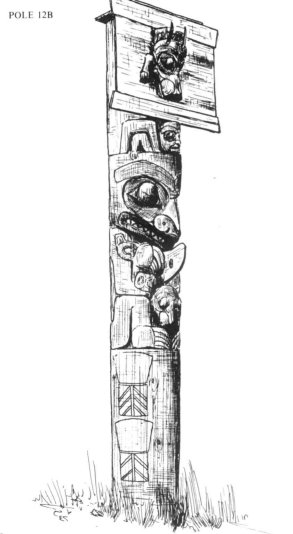

pole with the incised coppers remained upright.

The box front carried the carved head of the Haida version of the mountain goat. There are no mountain goats on the Queen Charlottes and the crest was one borrowed from the Tsimshian. As a design, the creature has little resemblance to the living animal, and more nearly represents a grizzly bear cub with horns. As this box front has the only unmistakeable mountain goat crest appearing in Skedans, and as the crest was supposedly a highly valued and often used one, it leads us to suspect that some of the other bear figures may have been intended as mountain goats, but the horns have disappeared. The model poles which Swanton purchased from native carvers in Skidegate in 1900 had several such bear figures without horns, identified by the carvers as being mountain goats, "but the horns had rotted off in the original."[27] On some Haida poles the artist had given the figure cloven hooves to re-inforce the goat's identity but not so at Skedans.

Beneath the box squatted a bear, similar to the one on Pole 4b which was also holding a killer-whale with a perforated dorsal fin. Once again one might assume that the large figure was simply the crest of the grizzly bear, except for the close bond with the smaller whale to suggest the sea-grizzly-bear identity. A human figure creeps forward to peer between the sea-bear's ears, in the spaces of which can be seen the man's hands and arms.

The incised coppers at the bottom of the pole were a sign of wealth, almost like a dollar sign. The prototype, beaten out of sheet copper, was exactly this shield shape, divided into three sections by a raised ridge in the form of a T. Real coppers that had been purchased at great expense in the first place, given away at potlatch and bought back at greater expense, took on inestimable value, much the way a valuable painting increases value by changing hands. There were four coppers on the base of this mortuary, two on each side and their value was obviously well known and appreciated at the time the pole was raised. They were an indication of the great wealth and importance of the chief interred within.

12c MOON-HAWK DOUBLE MORTUARY

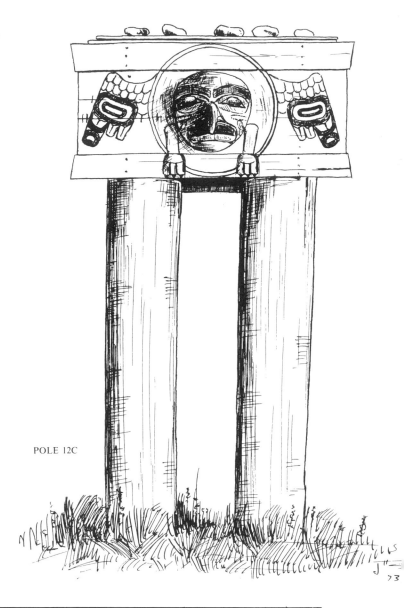

POLE 12C

If Haida art is finally being recognized as among the finest the world has known, then the Haida artist who produced this pole must rank high among the artists of the world. He has combined two ideas in a visual metaphor; the moon, which slips up the sky, only to glide imperceptibly towards the morning and the hawk, who floats above the earth, endlessly circling on silent wings.

The eye is drawn immediately to the sad stern features of the central face, the attention focussed and held by the double incised ring representing the moon. The face is human except for the nose which comes to a sharp point and bends backward to the human mouth, the sign of the Haida hawk. The wings, carved in low relief in an intricate pattern of feathers, are spread wide to hold the moon-hawk forever in his downward gliding rush.

The moon crest could be used only by a Raven chief and the hawk was also a Raven crest. The two ideas are often seen together on Haida poles. This double mortuary stood in front of the Raven chief's house and must have contained the remains of one of the most powerful of the town chiefs of Skedans. It is tragic that this particular mortuary board should be among the many to have disappeared without a trace. One support post and part of the other, are all that are left to mark its position.

FROM NEWCOMBE'S NOTEBOOK 1897

71

13 WINTER HOUSE

13a HOUSE FRONTAL

The thirteenth house in Skedans was called "Winter House," referring no doubt, to the fact that Skedans was a winter village of permanent habitations. The summer villages or camps, were only temporary and were erected in spots convenient to the natural food supply: salmon, shellfish and berries. When each 'crop' was harvested, the whole group moved on, only returning to the sheltered site of the winter village when the weather turned cold and stormy.

In Newcombe's time, only the frame of "Winter House" and the house frontal pole were left. Of the top crest figure he notes that it had an expression "like Punch", which seems appropriate enough. The immense nose hooks down and turns back into the mouth to depict the Haida hawk. Between the wings and the curled talons, the head and hands of another "spirit" figure appear, for the hawk too was said to have supernatural characteristics.

Newcombe described the second figure down as being "a bear with an immense long tongue and a child's head in mouth," and except for the absence of animal ears, the description fits well enough. The human figure emerging from the mouth looks more like a frog when viewed from the front, and the long tongue might also be an enlarged labret (woman's lip-plug), but in either case, it drops onto the head of the bear cub below, linking bear-cub, bear-human and human-frog into an entity which can only be described as bear-human-frog. Very likely it is linked with the bottom figure.

At the base of the pole is a figure that Newcombe described as also being a bear, but we tend to associate this bear-like figure holding a cylinder of wood with the Raven crest figure called Tca-maos, or Snag-of-the-Sand-Bar, whose fuller description appears on page 78. A frog at the bottom of the stick may be intended as a reminder that the Snag was supposed to be Trickster Raven in one of his disguises,[28] or it may only be a crest of the wife's. If we are correct in associating this bottom figure with the sea-grizzly of the Tca-Maos, then the bear-human-frog above his head may be an associate figure, either the wood-stick personified, the Raven in disguise, or the Tca-maos in a more human-like form. Other explanations are certainly possible.

This pole, belonging to a Raven family of the clan Those-Born-at-Qagials," has disappeared from the site. One resembling it from Tanu stood for a number of years at Prince Rupert, but whether this Skedans pole has fallen prey to the weather, or resides unidentified in a museum somewhere, we may never know.

POLE 13A

BIRD AND HUMAN HALIBUT HOOK

72

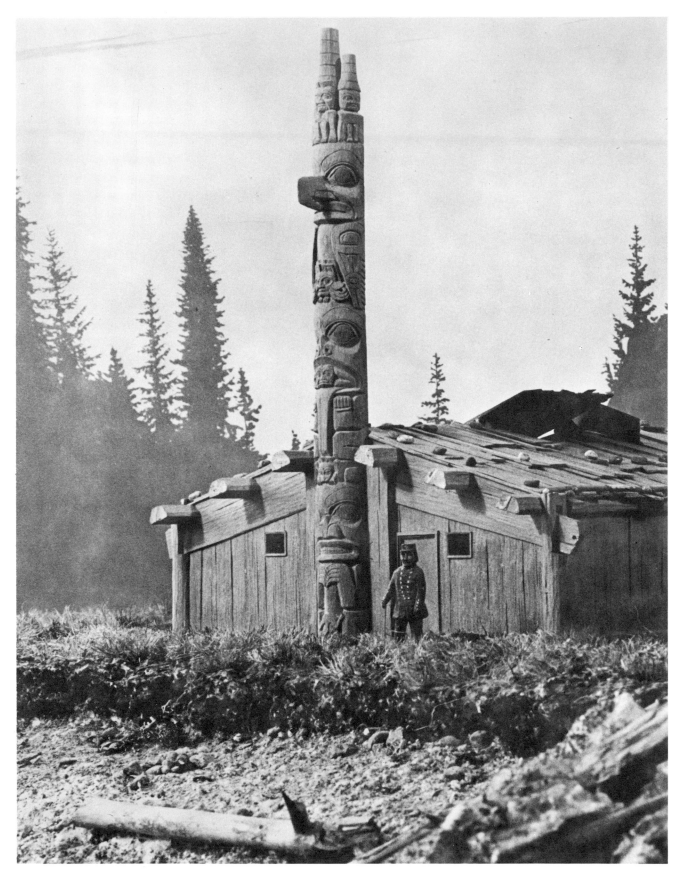

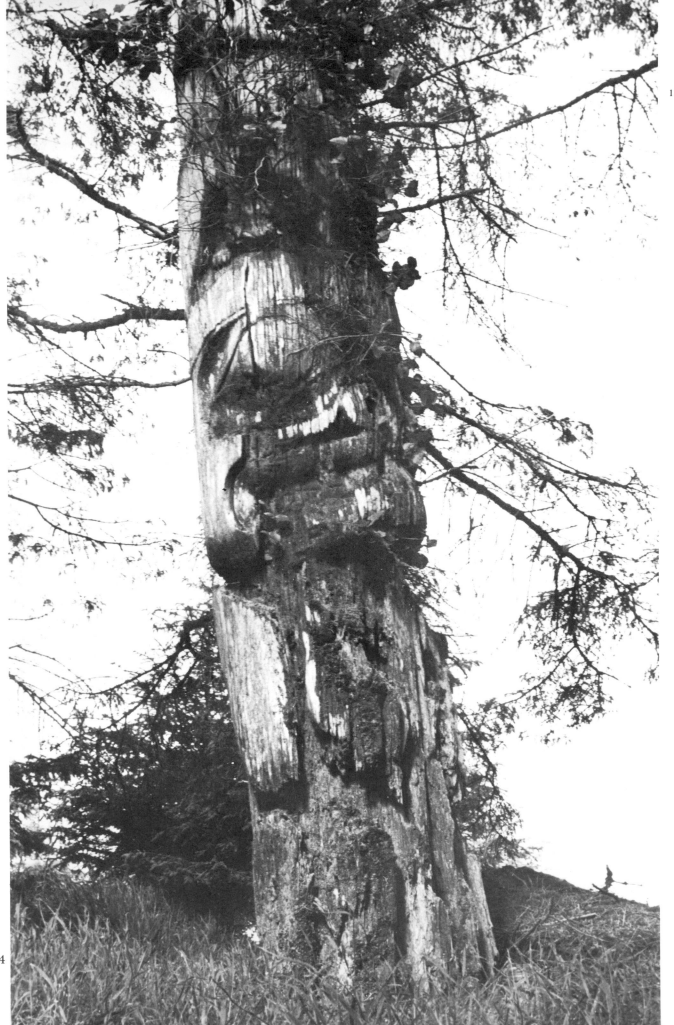

13b BEAVER MEMORIAL

13B

The beaver memorial was still standing in Skedans in 1957, but so badly decayed that the features were blurred and indistinct. It was about 47 feet high, and its hat was comprised of fourteen sections.

The cross-hatched tail, gnawing stick, enlarged incisors and round nostrils are almost identical with the other specimens. Here the artist made the mouth much wider at the outer corners so it loses much of its triangular shape. A small human figure is shown sitting on the upturned end of the beaver's tail, his arms hanging straight down, his knees drawn up to his chest. Bear cubs are coming out of the beaver's ears.

The meaning of these smaller figures has led to much speculation. The bear cubs, for example, cannot be said to be crest figures, for the bear is not a crest of the Eagle clan, as is the beaver. They may indicate a marital connection. The human figure might be that of the chief commemorated, or it might, as Dr. Newcombe[29] and others have stated, merely be ornamental. We cannot bring ourselves to agree. Just because the small figures cannot be explained now, or indeed, could not be explained seventy years ago, that should not lead inevitably to the conclusion that there never was a purpose other than ornamentation. When Indian informants said such figures were "unimportant", we feel they meant in comparison with the main crest. Being only a detail of the over-all picture they were soonest forgotten and have therefore been passed off as mere ornamentation.

There seems to be no way now to discover what each of these little figures was intended to mean.

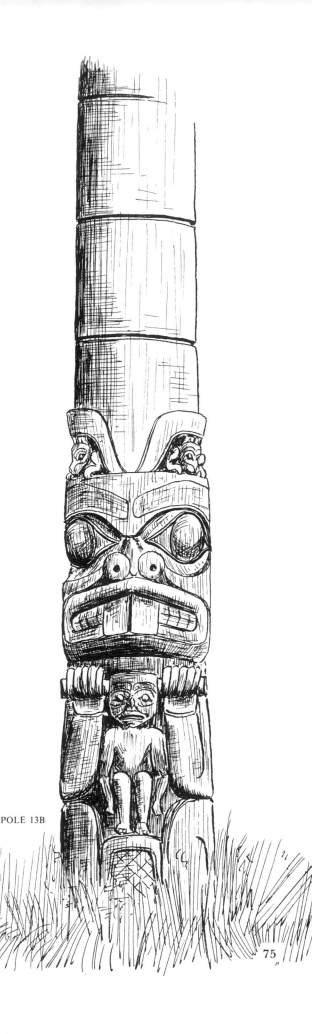

POLE 13B

13c DOG-FISH MEMORIAL

13C

Unlike the horizontal memorials which are sculptures in the true sense of being three-dimensional, the vertical memorials are more

POLE 13C

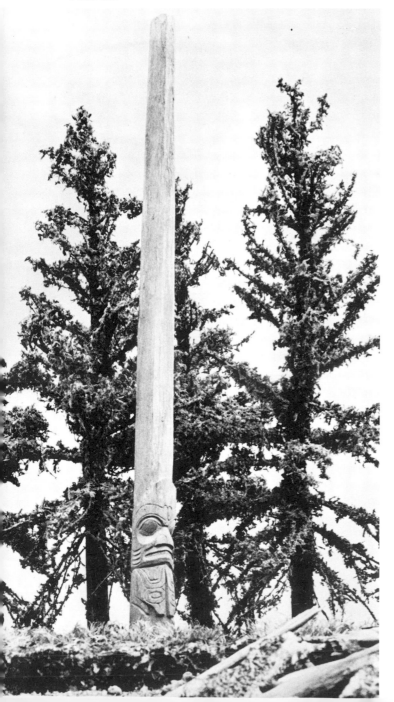

nearly two-dimensional. The curved front of the pole was treated as a flat surface and the back of the pole was ignored and left uncarved. Some of the front lines were carried around the back: the neck crease for example, was often carried right round the pole, but in all other respects the carvings were restricted to the frontal arc.

At the same time, however, the Haida artist made every effort to show the whole body of the creature he was illustrating. The body was fitted onto the pole either head-up or head-down, back out or belly out. Side, or profile views were very rarely used and do not appear on any of the Skedans poles. Most animal shapes could be bent to fit these restrictions of design. Land-animals sat up on their haunches. Whales could be shown head-down, their tails rising up the pole. If they sat upright, their heads were folded down and their tails were turned up to meet over their bellies. Some creatures were split up the backbone and spread apart so that both sides of their bodies could be shown, half on either side of the head.

The dog-fish was particularly difficult to represent in its entirety. His two most obvious characteristics, his dorsal fin and his mouth, appear above and below his body and could not be prominently displayed at the same time, except in a profile view. Shown from the top his saw-tooth mouth is lost from view. Shown from the belly his arc-shaped dorsal fin is lost.

The pole shows a compromise figure. It is belly-outwards, the downcurved mouth full of sharp teeth very much in evidence. The pectoral fins are folded forward under the chin. The tail is split and appears on each side at the bottom of the pole. The bullet-shaped snout of the dog-fish has become a "forehead" by the simple expedient of pulling the eyes around to fit over the mouth in a semi-human face, and by adding a human nose. Rising out of the back of the head is the impressive dorsal fin, almost thirty feet high.

The entire pole stood about forty-five feet high, near the corner of "Winter House," but now lies face down on the site, recognizable because of the tapered shaft. The carved portion is very badly decayed.

13d BEAVER MEMORIAL

George Dawson related a story told to him in 1878 of a gigantic beaver which inhabited the vicinity of Rose Point.[30] When the animal wished to come to the surface, he was told, it produced a dense fog, the water at the same time becoming very calm. He goes on to say:

> "The fog may, perhaps, clear away enough to allow someone watching in a retired nook to see the great beaver; but should the animal catch sight of any human being it instantly strikes the water with its tail and disappears. To laugh at the beaver, or make light of him in any way is certain to bring bad luck . . ."

A giant species of beaver appears on this memorial for it stands almost twelve feet high and has a diameter of 30 inches. It was raised to commemorate an important individual of the Eagle clan, whose wealth and importance are indicated by the number of incised rings on the property hat rising over the beaver's head.

The beaver is shown sitting up on its haunches. In order to show both his face and his tail on the front of the pole at the same time, his tail has been turned up in front of his stomach. The forelegs and front paws are raised to his chest where he clasps a gnawing stick.

The beaver here is shown with four large front teeth in a triangular mouth, instead of the usual two enlarged incisors. The flattened nose with rounded nostrils, the large eyes, the heavy eyebrows and animal ears over the forehead are the same as in other examples. The only difference, in fact, is one of omission, for the beaver is alone on the pole unaccompanied by any of the smaller figures, the so-called "space fillers", so common on Haida poles.

This memorial was still standing in Skedans in 1957, one of the very few poles remaining erect, but it was leaning backwards at an angle of about 70 degrees. A photograph taken in 1968 showed it still upright, much to our surprise, but the slant was greatly increased. The only reason such a pole remains upright when once it has begun to lean, is because its base is set into a six foot hole, and packed tightly with boulders as big as a man could handle. This seems to have been an effective device for keeping the poles erect, even in fierce windstorms, for most of the poles which have fallen have broken off at ground level where the rot has penetrated. One pole at Ninstints which had been "uprooted", fell only when the bank upon which it stood was washed away, exposing its boulder-packed foundation.

13D HANCOCK 1967

POLE 13D

77

14 MOUNTAIN HOUSE

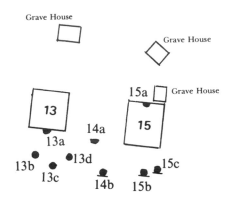

Grave House

Grave House

15a Grave House

13

14a

15

13a

13b •13d

13c 14b 15b 15c

POLE 14A

14a HOUSE FRONTAL

The fourteenth house in Skedans was called "Mountain House" and had belonged to the Raven family known as the "Peninsula-People," for most of them lived on the outer end of the curved peninsula upon which Skedans was built. This house had apparently burned to the ground sometime before Dawson's 1878 visit, but by some peculiar chance the house frontal was spared, and appeared very moss-covered in the photograph, in the middle of an open space. Dr. Newcombe mentions this open space contained the burnt timbers of a house, and a "partly burnt, prostrate totem,"[31] which has of course, subsequently disappeared.

The carving is of a completely different style from the majority of the poles in Skedans. It much more closely resembles figures appearing on the Kaigani-Haida poles of Alaska or of the northern villages of the Queen Charlottes. The features are picked out in low relief instead of the more common incised outlines.

All three of the main crest figures probably represent that mythical creature, the Tca-Maos, or personified Snag-of-the-Sand-Bar. According to Swanton:

> ... It is said that if this creature became angry, it would upset canoes by falling upon them or by raising a huge wave ... The special name of this being is Wigit, which would identify it as a form of the "trickster" Raven. [32]

The central crest holding a frog in its mouth and having feathers upon its elbows, most clearly resembles a form of Raven.

According to the Tsimshian legend,[33] three men went out on a raft, and tried to pull the Snag out of the water. (The central watchman holds what must be a snare of some sort, a rope noose on the end of a stick, and of course there are three watchmen to correspond to the three men of the legend.) The men succeeded in lifting the Snag out of the water and were astonished to find it covered with human faces. Looking under the water they discovered a huge grizzly-bear-of-the-water on whose back stood the Snag. The Snag now becomes personified and takes on a super-natural identity, separate from that of the sea-grizzly. In another version of the same story,[34] when the monster rose to the surface, a long fin first appeared, then a grizzly-bear-like-monster. Two of its offspring leapt from its body just before it was slain.

Many of the elements in this story can be seen on this pole, perhaps only by coincidence. The figure at the base of the pole is covered in human faces: on its paws, on its chest, and coming out of its ears. At the top of the pole, the main crest figure has no ears, perhaps indicating it is a piece of driftwood supernaturally made animate. Two smaller bear-like creatures with tails turned over their backs, perhaps representing the two off-spring, appear in the ear-spaces of the figure below.

Other explanations of this pole are easily possible, and once again we are the losers by not having Indian interpretation recorded at a time contemporary with the poles.

14b EAGLE, CORMORANT AND BEAVER MORTUARY

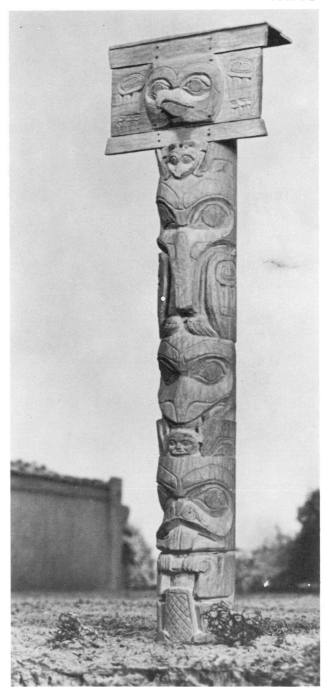

This mortuary stood slightly to the east of "Mountain House". The box front carried the large round head of the eagle with a low relief design of wings on either side. Shading on the photograph indicated that the supplementary design had been painted at one time and a few traces of paint had escaped the effects of weathering.

Poles were painted in certain areas to highlight the design in colours of red, black, white and turquoise. However, once painted they were never re-painted by the Indians and consequently very few traces of original paint remain. "Restored" poles, on the other hand, were often heavily coated with paint over the entire surface in an effort to preserve the wood but the effect is garish and unnatural.

Underneath the mortuary panel a small figure peered out, most likely a bear cub emerging from between the ears of the bird below. Here again we have the long-billed cormorant, crest of the Eagle clan, with its wings folded forward, its talons appearing below the tip of the beak.

The next figure down would appear to be a sea-creature of some kind, holding a human being in its mouth. Presumably, because of its lack of ears and lack of limbs, Newcombe calls this figure a "sea otter", but whether this was suggested to him by his Indian guide or whether it was his own interpretation is not known. If it is a sea otter, it would amount to a Raven crest appearing on an Eagle mortuary, almost a contradiction in terms.

The bottom figure is the easily recognized beaver crest, also belonging to the Eagle clans.

The pole could not be found at the site in 1957.

15 HOUSE PEOPLE ALWAYS THINK OF

The fifteenth house in Skedans had several names on Chief Skedans' list, because it was his house and he would be cognisant of the alternatives. "House People Always Think Of" was said to be the best name, but it was also called "House Raven Found" and "Raven House"[35]

"House People Always Think Of" stood in the middle of an open space near the center of the village and had escaped the fires that had des-

troyed the houses on either side. Of course it may have been built after the fires had levelled the other houses. It was in good condition, even in 1897, and was one of the few at that time occasionally inhabited although its owner had moved to Skidegate. By 1905, Chief Skedans was dead, taking with him a vast store of information about the village, only a very small portion of which was ever written down.

Nothing now remains of the house. It was the only six-beam house in Skedans in 1878 without a house frontal pole. This was particularly strange as it belonged to a chief but it would be a further indication that the house may have been more recently built than the others. By the time Chief Skedans would have accumulated enough wealth to raise such a pole, disease had all but wiped out his people, totem pole carving was being met with official disapproval, and the long road away from home had begun.

DESIGN FROM RAVEN BRACELET

15a EAGLE AND CORMORANT INSIDE HOUSE POST

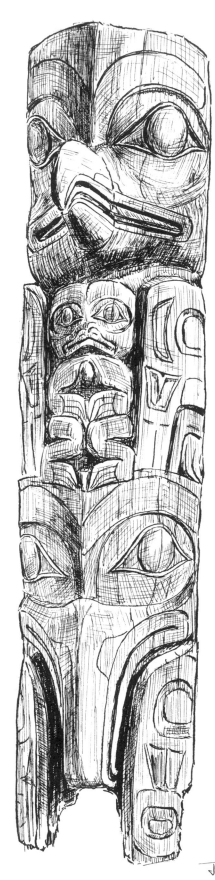

Initially, the only record we had of this inside house post was a line drawing in John Swanton's *Contributions to the Ethnology of the Haida.* The original pole was collected for the American Museum of Natural History, and a recent photograph from that Institution shows it to carry two crests. Swanton describes it as follows:

> . . . obtained for the American Museum of Natural History by Dr. Newcombe. Although it was the inside pole of a house at Skedans, it belonged to William and Timothy Tait of Ninstints, who derived the right to it through their mother. The upper figure is an eagle, the lower a cormorant, — both crests of the Eagle clan, and probably in this case of the Ninstints Giti'ns.[36]

For a long time, then, we knew that this pole had been removed from Skedans, sometime before 1900 when Swanton's book was researched, but that was all we knew about it. There seemed no way of ascertaining from which house the pole was removed until Dr. Newcombe's manuscript notebook came to light in the Provincial Archives, Victoria. The notebook was dated 1897 and was a record of the houses and carvings at Skedans at that date. It contained rough, hurried, almost indecipherable notes and "sketches", but it has provided us with many missing links.

Sometime after 1897, Dr. Newcombe had gone back through his notes adding a comment here and there. Beneath his description of an inside house post in the vicinity of "House People Always Think Of" he had added "T. Tait's, at N.Y. See Sw. Fig. 8, p. 128," and thus solved for us the mystery of the original location of this inside post.

POLE 15A

81

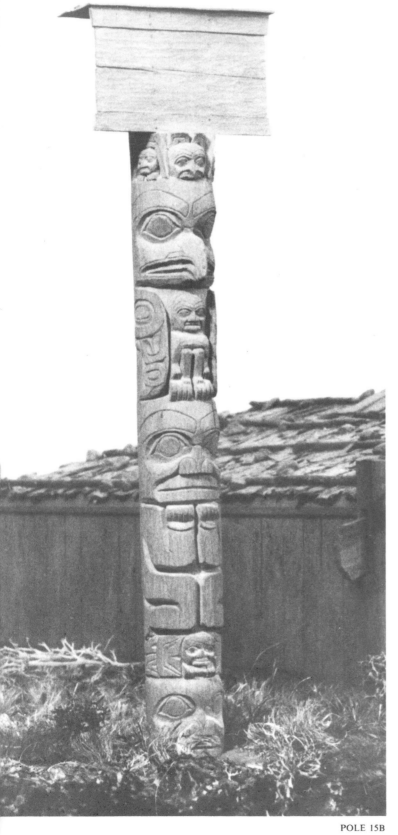

15b EAGLE AND CHIEF MORTUARY

"House People Always Think Of" was the only six-beam house in Skedans to have no house frontal pole but by way of compensation, it had in front the tallest mortuary of the village. The frontal boards appeared perfectly plain and no trace of a design remained.

The pole was carved before it was erected, of course, with the wider, butt end of the log hollowed out for the grave box. Presumably, the huge frontal boards must have been nailed on while the pole was prone. The lowest frontal board was nailed on an uncarved strip of solid post but the other frontal boards closed in the four-foot opening. The back of the pole, left as a shell, formed the back and sides of the chamber.

Once the pole was raised into position, the grave box was let down into the top and a plank laid over as a lid, nailed on and weighted with rocks as an extra precaution. A potlatch was held in connection with the raising ceremony, where the carvers of the pole and all helpers were paid. At the same time the rights and possessions of the dead man were formally given over to his inheritors.

The top crest figure is an eagle with human faces appearing in the ear spaces. A similar convention at Skidegate was said to represent the son and daughter who had paid to have the pole raised for their father. Another smaller eagle head appears overhead and a human sits between the wings.

The second major crest figure is a human being. The absence of any lip ornament suggests it was intended as a male and it may represent the chief interred within.

The bottom face is so hidden by grass that it is difficult to make out any specific features other than the eyes, without the eyebrows for once. Above the head, on either side of the small human face, appears a design which may represent ears, wings, or flippers. There is a strong suggestion of the sea-creature about this large crest, but we cannot positively identify it.

The pole has fallen.

POLE 15B

15c BEAR AND KILLER-WHALE MORTUARY

Emily Carr wrote of Skedans that the old poles never lost their dignity, no matter how drunkenly they tilted, but she visited Skedans before the forest took over. Since then, a vigorous army of young conifers has marched forward rank on rank, to over-run the village, surround the poles, and pressing on to the very edge of the sea, has blocked out the view over the bay.

The Bear and Killer-Whale Mortuary has had a hemlock seedling sprout directly at the foot of the pole. As the trunk of the young tree expanded, the poles was forced backwards and bears a grotesque resemblance to a man watching a parade who has had a rude newcomer elbow his way into the front ranks and tread heavily upon his toes.

The figure wears an agonized expression, too polite to shout or curse, while the interloper goes on growing, cheerfully unaware of the distress and humiliation it is causing.

The pole may have lost its dignity, but it has not lost the appearance of being able to see out of those wooden eyes. All eyes at Skedans face the bay, all eyes give the uncanny impression of sight, but now the trees stand in the way.

It is difficult to imagine that only ninety years ago the site was level and clear, the carving on the poles sharp and distinct, and the houses stood sturdy and comforting.

A grizzly bear's head appeared on the box front. The ears were separate pieces jutting forward. It was identical with the bear frontal boards of poles 6b, 18c and 20c, and there is no reason not to assume that they were carved by the same artist.

The killer-whale, held by his "spirit" companion is also repeated several times on the Skedans poles, and many times on other Haida poles. The human figure is usually identified as Gunarh, whose wife was carried off by the killer-whale people, or else as the Strong-Man, who with supernatural powers was able to hunt whales. Neither of these legends, however, actu-

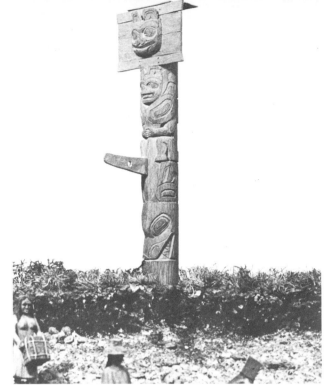

POLE 15C

ally mentions the hero riding or clutching a *killer*-whale in the fashion always apparent on the poles.

If any Haida legend is repeated in connection with this crest it ought surely to be one collected by Swanton which purports to tell how the killer-whale crest came first to be used.

> . . . Two men of the town of Tian chased a wounded buffle-head out to sea, and were taken down to a killer-whale's house at the bottom. One of these was fitted with fins and became a killer; the other, . . . escaped.[37]

The legend goes on to relate how the human brother went out hunting whales with his killer-whale brother, until the death of the latter at Rose Spit. When the people went there they found the body of a killer-whale on the beach and raised a mortuary column for the dead brother, bearing the crest of the killer-whale.[38]

When the killer-whale crest is shown with one "spirit" figure, we like to think it is intended to be the unfortunate brother who had been turned into the killer-whale which he clutches so desperately. When another smaller human figure is shown on the killer's back, as in Pole 2a, it may be the human brother accompanying the killer-whale on a whale hunt. Because we feel this story fits the illustration more closely than any other interpretation we have included it, but it is not necessarily the correct one.

16 GRIZZLY BEAR HOUSE

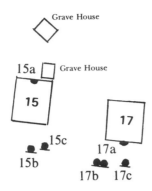

The sixteenth house in Skedans was gone by 1878, and presumably was destroyed by fire, but Chief Skedans had recalled it belonged to a Raven family of the clan known as "People-of-the-Town-in-McKay's-Harbour." The house had been named "Grizzly Bear House", one of several of that name in Skedans. We have no information about it, other than this, for there is no photograph of it.

Prior to the photographs, there were only the written descriptions by early visitors to the villages, whose impressions drawn from their travels were often published upon their return to their homeland. Historians are alternately pleased and frustrated by what can or cannot be gleaned from these accounts. So many things we would like to know have been omitted — so much of what has been written is subject to varying interpretations.

Some travellers, for example, mention only the smallest works of Haida art; the canoes, garments, dishes, spoons, but make no mention at all of the houses or totem poles. It is difficult to imagine that even the most world-weary of navigators could fail to be impressed by unusual carvings of such a size as the totems. Some historians, therefore, have presumed that there must have been no poles at that date. But Europeans visiting these shores were often too suspicious and cautious to venture ashore on unfamiliar territory. Traders often stayed on their ships, anchored well off-shore as a safety measure, and let the trade canoes bring furs out to them to be bartered on deck. Such traders would obviously see only the small carvings and

tools brought out to them, and never putting ashore at the village site themselves, would fail to see the houses and totems tucked away in sheltered bays.

Those travellers who forgot their personal anxieties long enough to venture ashore, however, wrote vivid accounts of the houses and totems, which were, in all likelihood fewer in number than later on. In 1790-93, for example, John Bartlett gave the following description of a Haida village:

> . . . We went ashore where one of their winter houses stood. The entrance was cut out of a large tree and carved all the way up and down. The door was made like a man's head and the passage into the house was between his teeth and was built before they knew the use of iron.[39]

And Captain Vancouver, describing a mainland village, makes an important observation:

> . . . the larger (houses) were the habitations of the principal people, who had them decorated with paintings and other ornaments, forming various figures, apparently in the rude designs of fancy; though it is by no means improbable they might annex some meaning to the figures they described, too remote or hieroglyphical for our comprehension.[40]

This inability of early traders to communicate with the Indians in anything but sign language made it impossible for them to exchange ideas and to understand the meaning of what they saw. The misunderstandings which arose led to the disputes and deteriorating relationships which have plagued us ever since, and have prevented us from inheriting detailed and accurate descriptions of early villages.

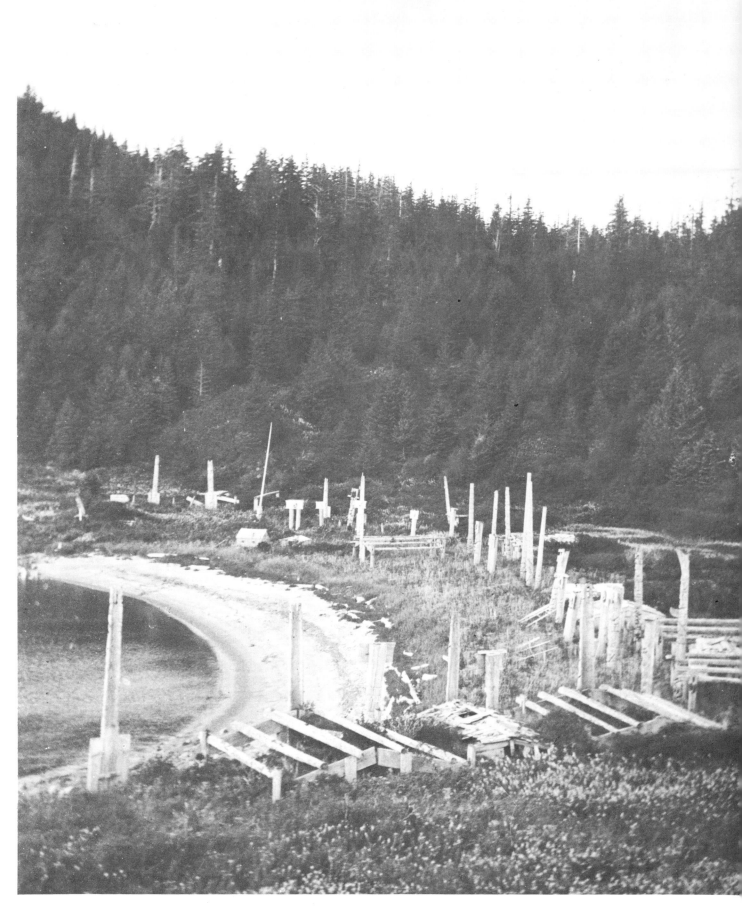

17 GROOVED BARK HOUSE

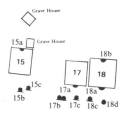

17a HOUSE FRONTAL

The seventeenth house in Skedans, which also belonged to a family from the clan called "People-of-the-Town-in-McKay's-Harbour", had an unusual name. It was called "Gooved Bark House" because the main house beams still showed the marks where the bark had been removed in long strips. It had as its frontal pole a column which even Dr. Newcombe described as being "very old" in 1897. The figures on it are depicted in a different style of carving, and unlike most of the house frontals, seem to tell a story rather than illustrate crests.

The hero of the story appears in the legends of several tribes and was known as Kag'waai by the Haida, or Konakadet by the Tsimshian. Translated freely, the name means "Strong Man Killing Killer-Whales and Sea-lions." The human figure on the pole, second from the bottom, is shown in the act of tearing a sea-lion in two and is the representation in human form of Strong-Man. A small killer-whale at the top between the watchmen may represent the second victim mentioned in his name, but these small killer-whales appear on other Skedans poles as well.

From the time he was a small boy, Kag'waai possessed the ability to don the skins of animals to obtain supernatural powers. He used a halibut skin to travel beneath the ocean. He was swallowed by a whale, as depicted in the bottom figure on the pole, and killing the whale from within, he then travelled about the ocean, still inside the whale's body. He was said to have trapped the sea-grizzly and entered its skin, and in the parallel legend of Su'saan, to have trapped the sea-wolf Wasco, either of which mythological beast may be represented at the top of the pole in bear-like form. This semi-human

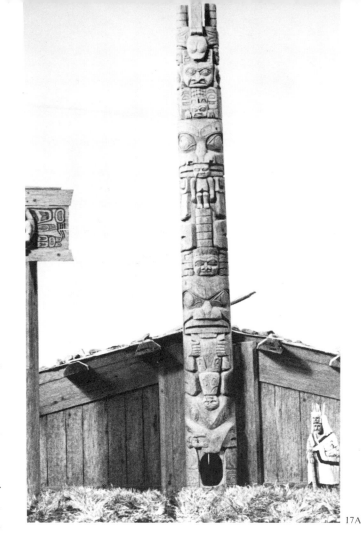

17A

creature with animal ears and human limbs is also provided with a segmented tail resembling a dance hat, but with fins at the base indicating a sea-nature very much like the sea-grizzly of the Tca-maos crest.

Eventually Kag'waai entered the bay of Skedans, came ashore, took off his magical halibut skin and hung it to dry on the limb of a tree. Falling asleep, he was awakened just in time to see an eagle stealing the precious skin from him, but as he made preparations to give chase, a voice from the forest called out, "Don't touch the eagle. Your grandfather lent you this skin. Now it is being taken from you." And Strong-Man became human once more.[41]

An eagle is also represented on this pole, in the group with the watchmen at the top, but its diminuitive size and the "spirit" head at its feet makes it fairly certain that it is intended to be the eagle of the story, rather than a crest figure.

No trace of this "very old pole" remains at the village.

ROG DESIGN

SKEDANS DAWSON 1878

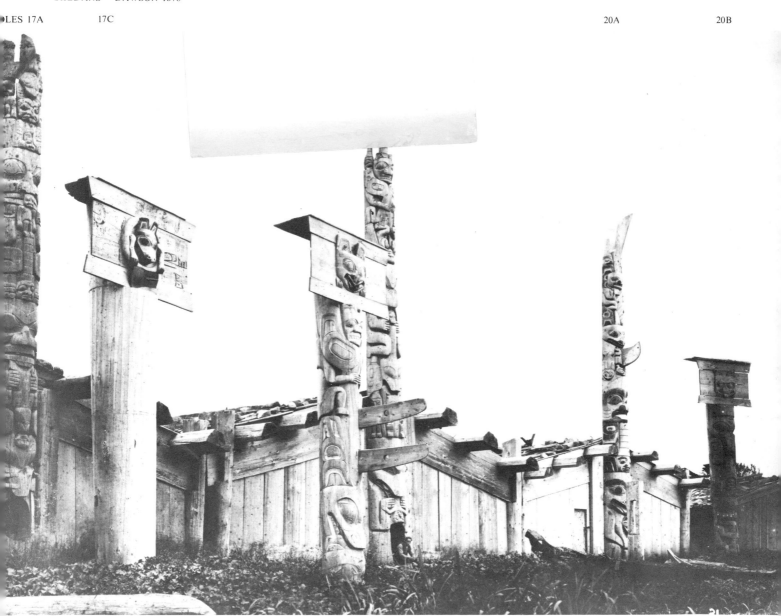

17b BEAVER DOUBLE MORTUARY

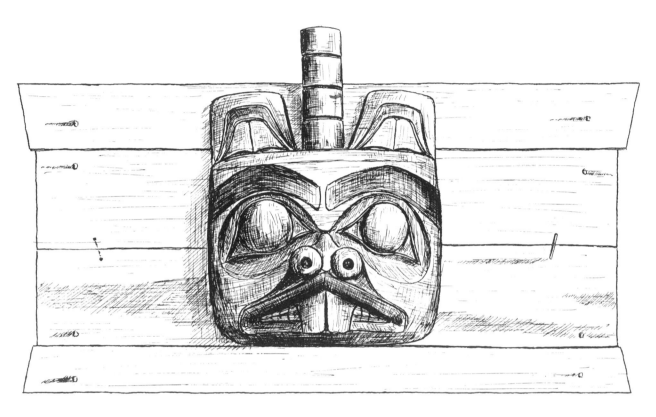

POLE 17B

The third double mortuary in Skedans, carrying the beaver crest of the Eagle clan, stood in front of "Grooved Bark House." Like the other mortuaries, the posts were set butt upwards, but the double mortuaries were not hollowed out in the fashion of the single ones. Instead, the grave box rested on a shelf between the posts.

The beaver's face, which was almost four feet across by three feet high, was a separate carving nailed into place. The ears and the usual property-hat were also separate and were mortised into the top of the head. The design seems almost stark in its simplicity, but the rest of the frontal board was probably painted originally and the paint had weathered off by the time the pole was photographed. It was difficult for Haida artists to leave space unadorned, and it seems unlikely that it was intended to be so plain. Once painted and erected, of course, the poles were never repainted or repaired, for another potlatch would have been required for the ceremony with no further honour or prestige as a result.

The posts of this mortuary were still standing in 1968. The front, like all the others, was gone.

17c BEAR AND COPPER MORTUARY

The box fronts of mortuaries seem particularly vulnerable to decay, and once fallen from the pole, usually disappear in a very short time. Some of those presumed to be decayed, however, may have found their way into private collections, so it is fortunate that a few have been preserved for the benefit of everyone in public museums. The bear box front illustrated here, for example, now rests in the museum in Prince Rupert, B.C.

The bear is shown emerging from a double ring which supposedly represents his den. A similar figure adorns a Tsimshian pole at Kispiox, on the upper Skeena River, and indicates, if nothing else, the exchange of ideas and designs between the Tsimshian and the Haida. The surrounding boxfront on the Skedans pole was painted with a design representing the bear's body. His hind feet appear at the upper corners of the box and what might be the dorsal fin and pectoral fins of the sea-grizzly appear in the center and at the bottom of the frontal board.

The bear is shown holding a copper, which was not a part of the carving, but was a real copper, beaten out of sheet metal in the traditional shape, and nailed onto the pole. The design, resembling a shield, has been around for some time and was supposed to have been beaten out of native copper ore before sheet copper was available in trade. But no example of a "native ore" copper has survived to support this theory, and the premise has been challenged.

In any case, the coppers represented a great deal of wealth, had their own names as did the houses, and whenever they were transferred, broken, riveted together again, or deliberately destroyed, the ceremonial actions were accompanied by elaborate rituals and songs. The copper on this mortuary had disappeared long before the Prince Rupert Museum acquired the board, and there is no way of knowing its eventual fate.

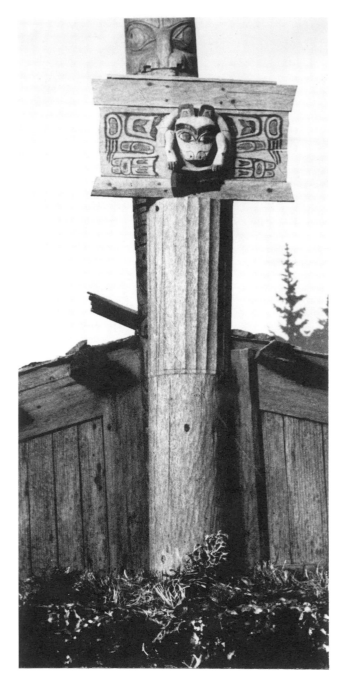

POLE 17C

The support post of the mortuary, fluted along the upper half, is still standing at the site. It is unusual, however, in that two rectangular mortises appear in the back of the pole, about four feet up from the ground. If they are original to the pole, they may have been used to help erect the column, but as they do not occur on the other mortuaries, it would not seem to be common practise.

89

18 GRIZZLY BEAR MOUTH HOUSE

18a HOUSE FRONTAL

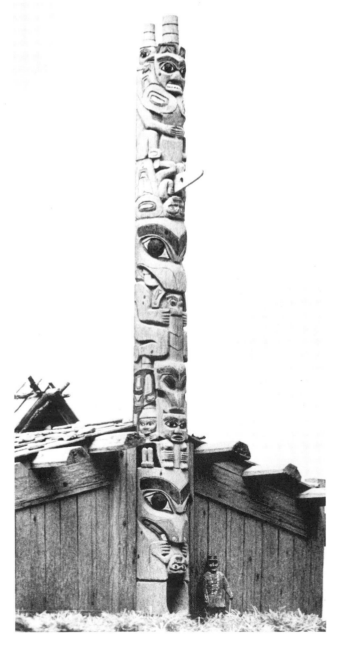

Grave House

18b

17 18 20

17a 18a

17b 17c 18c 18d

20a

20b

20c

POLE 18A

"Grizzly Bear Mouth" was the name given to the eighteenth house at Skedans, and it belonged to a Raven family of the "Peninsula-People" group. Apart from one house already mentioned, the "Peninsula-People" were clustered together at the eastern end of Skedans, on the peninsula from which they drew their name, and "Grizzly Bear Mouth" was the first of the cluster.

The house frontal pole had the traditional doorway through the base figure, and its position below the mouth of the grizzly bear gave the house its name. The lower limbs of the bear were hidden in the grass, but the fore-paws were shown holding a human figure upside down. Upended figures were sometimes put on a pole to ridicule a debtor who refused to pay what he owed, but several of the bear legends included persons who were killed by bears, and one of these may be intended.

Above each of the bear's ears was a figure wearing a property-hat, much like the usual watchmen figures, but here probably representing chiefs of the clan. In between the two chiefs is the body of another human figure squatting above the bear's forehead and wearing a peculiar form of headdress. The headdress is held in the mouth of a sea-creature, whose flippers fold over the hats of the chiefs on either side. The head of the sea-creature is continued upward with a chevron design on the spine similar to the sculpin's, but as no sculpin spines are apparent over the mouth, we are not sure which sea-creature is intended here. These fantastic animals woven into a design hold the same fascination for us as the intertwined characters of medieval Anglo-Saxon art.

The next figure above is particularly interesting. At first glance it is a bear with a seal's head emerging from its mouth. In place of ears, however, pectoral fins turn upwards along the sides of the pole, and between them appears the body of a killer-whale, ridden by one human figure, tail held by another human figure at the top of the pole. This odd combination is the sea-grizzly-bear in its full form: a grizzly-bear and a killer-

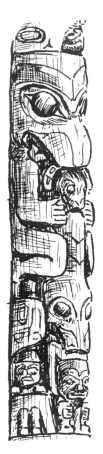

POLE 18A

whale sharing the same head. The perforated dorsal fin which had been mortised into the whale's back had fallen off before the 1878 photograph, but the "spirit" figure at the top is the same one to occur with all the other major killer-whale crests in the village, so there is no doubt that the killer-whale was intended.

The two watchmen on either side of the "spirit" figure are facing forwards and one arm of each rests on the whale's tail. There may also have been another small figure, an eagle or a small killer-whale fastened onto the top of the hat of the central "spirit" figures, for the shaft has been notched and three nail holes can be seen. Whatever was there, however, had fallen off before 1878.

Despite the complexity of the design, only two major crest figures are represented here: the sea-grizzly at the top of the pole, and the grizzly bear himself at the bottom. Both are crests of the Raven clans. This pole has disappeared.

LONGHOUSE REMAINS 1953 DUFF

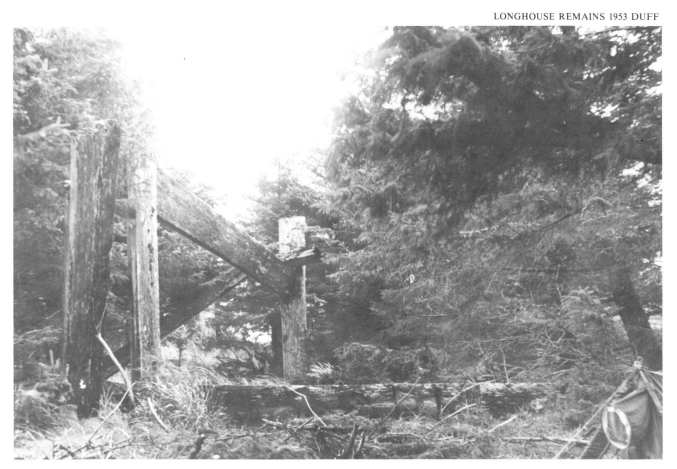

91

18b EAGLE AND BEAVER
INSIDE HOUSE POST

This inside house post was the last of three such posts in Skedans that have come to our attention. Our record of it comes from Marius Barbeau's *Totem Poles,*[42] and the drawing is taken from a photograph of the pole as it stands in the Field Columbian Museum in Chicago. Dr. Newcombe apparently provided the accompanying information, saying that the pole carried the crests of a woman belonging to the family of "Those-Born-at-Skedans" of the Eagle phratry, and adding the comment that it may have been erected at Skedans about 1875.

The eagle, whose talons appear in the beaver's earspaces, is associated with a "spirit" figure whose face intercedes between the beaver and the segmented property hat which the beaver usually wears, making it difficult to ascertain to whom the property hat belongs. The beaver also holds a "spirit" figure in place of the usual gnawing stick, and another small bird's face decorates beaver's tail. Dr. Barbeau mentions that the spirit figure associated with the beaver may allude to the Raven in human form.[43]

The little figure possessing supernatural powers, therefore, may be Raven in human form, and the little face on the tail, the Raven's companion, Butterfly.

POLE 18B

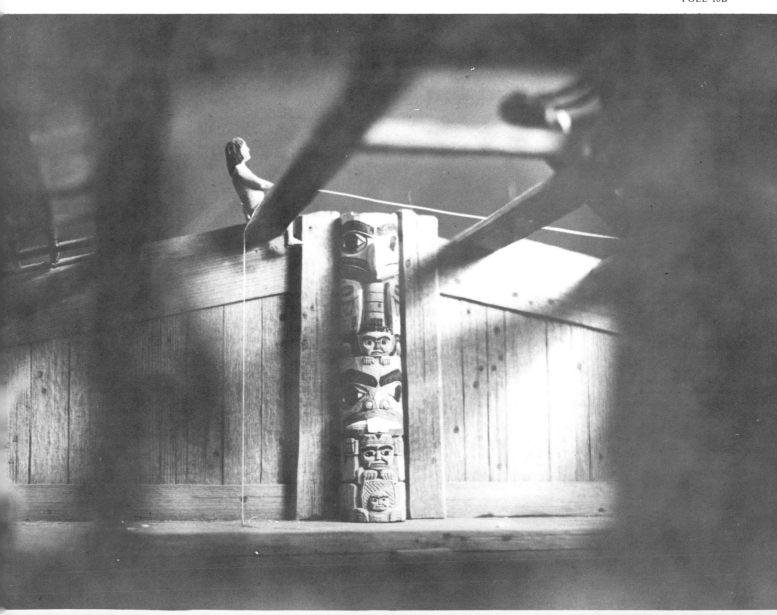

18c BEAR AND KILLER-WHALE MORTUARY

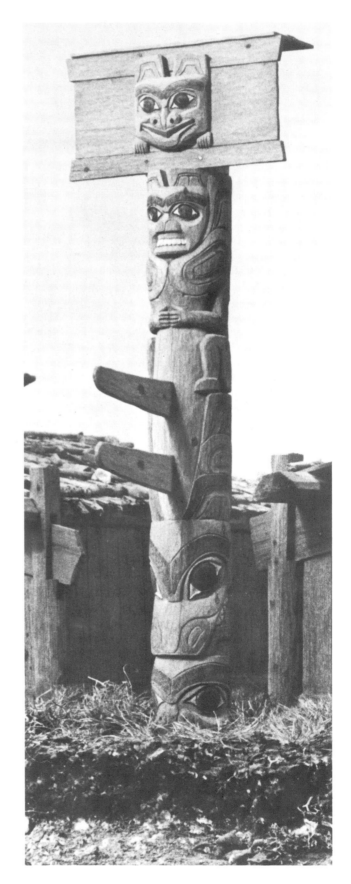

POLE 18C

The mortuary shown here is a near twin to the mortuary pole 15c, and is repeating crests which appear time and again on Haida poles. The grizzly bear on the box frontal boards is the beautifully designed and executed figure seen on several Skedans poles and on a carved Haida rattle in the British Museum collection, which could have come from this village, its features are so alike to the ones here.

Like so many of the mortuary fronts, the fastenings soon deteriorated, allowing the boards to drop off and disappear. It is difficult to imagine that natural destructive forces are responsible for the loss of all the mortuary boards but two. We still hope to find record of some boards in private collections.

The killer-whale, a crest of the Raven clans, is nearly always shown with its head down, its perforated dorsal fins prominently displayed, and its tail clutched by a human figure wearing an agonized grin and animal ears.

The head at the bottom of the pole, an animal of some kind, is hidden in the grass in the old photos, but some of the features may even be below ground level. Poles were carved and painted before they were erected, and an uncarved portion was left at the bottom to be sunk into the ground. It may have occasionally happened that some error of judgment caused part of the pole to be buried.

The mortuary remains at the site but it has fallen.

18d FALLEN MEMORIAL

Despite the fact that totem poles are supposed by some to be relatively recent, and erected not long before 1870, Dawson speaks of some being old and moss-grown in 1878 and at least one of the poles at Skedans had already fallen by that date. Pitched face-forward onto the beach, and hidden by canoes, long grass and driftwood logs, only the back can be seen. It appears to be divided into segments like the dance hats of the beaver memorials still standing in the village.

The bottom end cannot be seen at all, but it was not likely that it had been deliberately cut away or destroyed, for no attempt seems to have been made to clear the rest of the fallen pole out of the way of the foot-path in front of the houses. Apparently the people were willing to go a step out of their way rather than disturb a memorial, even a fallen one, to a departed chief. There is a message here for modern traffic engineers.

POLE 18D

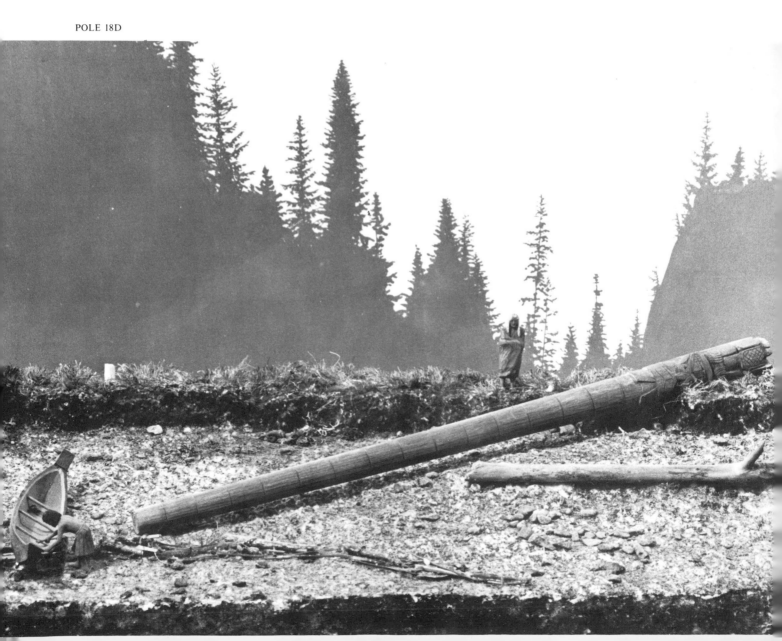

COAST FOREST

19 HOUSE WITH TWO HOUSE POLES

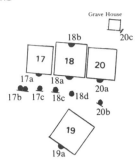

Tucked into the eastern corner of the U-shaped bay was the second house, closer than the other to the beach, and once again it was difficult to decide where it came in on Chief Skedans' list of house names. Complicating matters at this point was the fact that we could find photographic evidence of ten houses remaining in the village, but according to Chief Skedans' list, there should have been eleven. The random shots of early visitors, taken as souvenirs rather than as scientific records, do not provide a complete picture of the eastern turn of the village. Somewhere in that right-angled bend a house has either eluded us, or else Chief Skedans' memory played him false. In either case, by Dr. Newcombe's visit, the house, if it ever existed, did so no longer.

Between Dr. Newcombe and Chief Skedans, however, we came to the conclusion that the nineteenth house, named "House With Two House Poles" was the one in the corner close to the beach. It had only one house pole erect, as a matter of fact, but another carved pole lay on the beach, covered in protective blankets and was used as a convenient propping place for paddles and various bits of wood. It did not look as though it was in the process of being carved, but rather as if it had been finished and was awaiting the gathering of wealth required for the raising ceremonial and accompanying potlatch. How long it had lain there, and where it was intended to be erected, must remain a matter of speculation.

Poles were still being raised in 1878, but obviously not as often as at one time, as the population of Skedans was sadly reduced from its former strength, and more and more the trend was towards leaving the old village sites altogether. Another pole was raised after Dawson's photos of 1878, however, as a new one appears in Newcombe's photos of 1901, which did not show up in the earlier photos. Once again, the angle of the photo may be to blame. It is very difficult to make a definite judgment on whether a pole or structure was there at a given date, even with a photo as evidence. If the house was set back from the others only a few feet, or if the pole was close to another and the camera set up at some distance, the difference of a degree or two of angle can either reveal it, or hide it from the viewer.

The pole on the beach, therefore, may have been raised at a later date, and be the one defined here as 24b.

The house pole of the nineteenth house, "House With Two House Poles," appears as pole 19a.

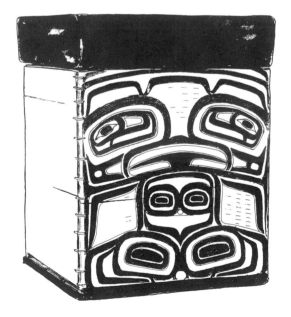

HAIDA STORAGE BOX

19a HOUSE FRONTAL

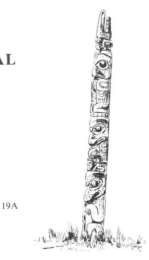

19A

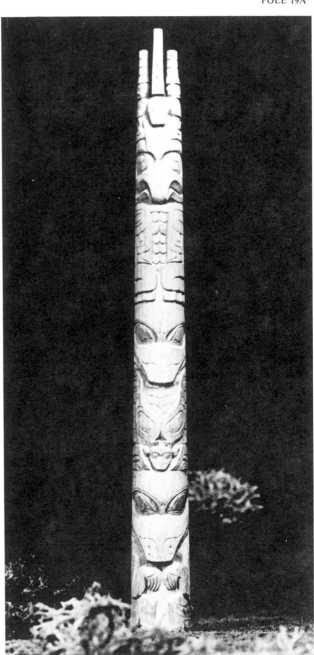

The nineteenth house belonged to a family of the "Peninsula People." At the top of the pole, protectively embracing the two watchmen with its pectoral fins, is a small figure of a whale, perhaps a killer-whale, although there is no perforation in the fin. It may be intended as a clue to the geneology of the owner.

The top crest figure is that of the Haida thunderbird or hawk. It strongly resembles the hawk on the mortuary 6c page 51, with its snubbed beak, its half-moon eyes, its semi-human combination of wings, hands, and feathered human knees. As previously mentioned, both Eagles and Ravens had a hawk among their crests, but on this pole, the hawk is combined with a whale above and below, and the combination of hawk and whale usually denotes the thunderbird who hunted and fed upon whales. The thunderbird is a Raven crest.

The whale below is an ordinary, or black or baleen whale. Its flukes are turned up on its chest, its pectoral fins are folded down like wings. The broad flat snout and toothless mouth are particularly noticeable in this strong, symmetrical carving.

Another Raven crest, the grizzly bear, appears at the bottom of the pole, a little bear cub peering through its ears. The bearcub's paws fill the ear spaces of the larger figure in the usual way.

The pole has disappeared from the site, its exposed position close to the beach making it more vulnerable, both to the effects of the weather and the possibility that high tides might carry it out to sea. Its ultimate fate is not known to us.

20 GRIZZLY BEAR HOUSE

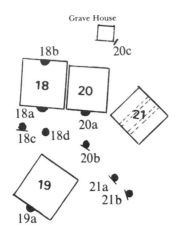

Grave House

18b

18 20

18 20c

18a 20a

18c 18d

20b

19 21a
 21b

19a

20a HOUSE FRONTAL

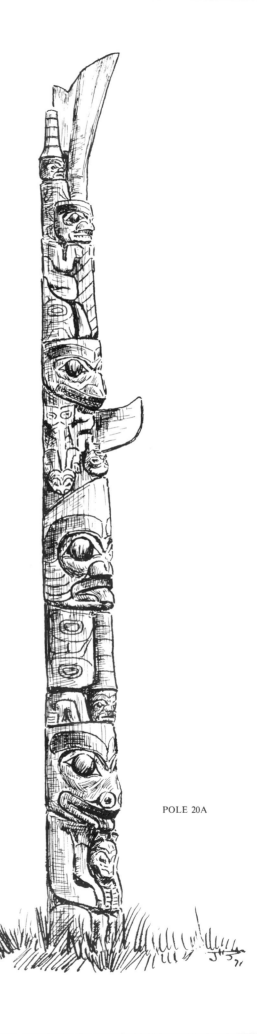

POLE 20A

The "Grizzly Bear House" was another belonging to the "Peninsula-People" of the Raven clan. The Raven crest of the grizzly bear at the bottom of the pole gave the house its name in all probability, and contributed also to the nickname "Grizzly Bear Town" for Skedans. Besides being a crest figure, however, the presence of the bear cub, held in an affectionate embrace, may be intended to recall the legend of Bear Mother, a popular tale among the Northwest Coast tribes.

In the Bear Mother legend, a young woman was picking berries on the mountainside with her companions, and instead of singing to warn the bears of her presence, she fell to mocking and jeering at the bears for their droppings, into which she had stepped. She then became separated from her companions, and while making her way home alone, met a handsome young man who accompanied her. He led her to his village where it became apparent that he was a grizzly bear in human form, and had kidnapped her to make her account for the rude things she had been saying. The young woman eventually married the grizzly bear and had two children by him, becoming part bear herself.

On the poles, Bear Mother may be represented in human form with a labret to distinguish her sex, or in the traditional grizzly bear guise, but accompanied by her two offspring — either two cubs, or one cub and one human child, or two

little chiefs, indicating the changeling nature of the cubs. On this pole, only one cub is being held. The human head wearing a property-hat which appears between Bear Mother's ears may indicate the second human "cub", or may be a portrait of the chief who owned the pole, and who was thus a more distant "descendant" of Bear Mother. While the legend is of some antiquity, the pole itself was not one of the older ones, for it was carved after the hinged door-ways to the houses became popular.

On either side of the chief's property hat are the broad pectoral fins of the dog-fish whose pointed head appears centrally on the pole. Instead of the rows of sharp teeth usual to this figure, he has been given a protruding tongue, but the gill lines in his cheeks, the domed "fore-head", the projecting curved dorsal fin, and at the very top of the pole, the heterocercal tail, make his identity unmistakeable.

Riding upon the dog-fish's back are a host of other creatures, large and small. The projecting fin is clutched by a human "rider", and he is flanked on either side by seals, or sea-lions.

NATIONAL MUSEUM PHOTO

Overlapping the dog-fish's body, as though they too were riding on its back, are a human figure and the sculpin he is holding onto. Once again, the sculpin, or bullhead, is shown with a wide up-turned mouth, two spiny projections above his forehead, fins turned up along the sides of the pole, and a series of chevrons designating his backbone. His tail, divided like a whale's flukes, appears behind the head of the human figure, just under the head of the watchmen at the top.

In 1935 this fine totem was removed to Prince Rupert, by which time the dog-fish's tail at the top of the pole had broken off. When the pole was erected in Prince Rupert, it was painted to protect it from the weather, and for some reason, a third watchman was carved and placed in the gap where the dog-fish's tail had been. It stood that way for many years, but continuing difficulty with preservation caused it to be shipped to the Provincial Museum in Victoria. The move necessitated its being cut into three pieces. Its condition is such that it will probably never again be displayed, but will remain in storage for the benefit of the serious student.

POLE 20A WAS RE-ERECTED IN PRINCE RUPERT PARK IN 1935. IN 1965 IT WAS TAKEN TO THE PROVINCIAL MUSEUM.

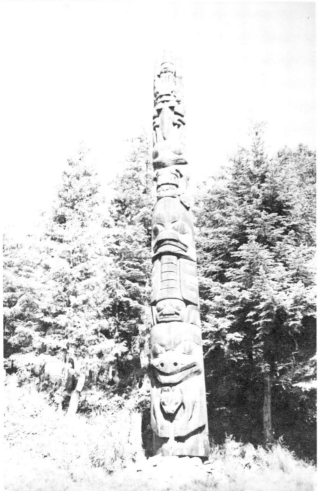

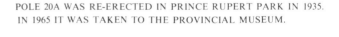

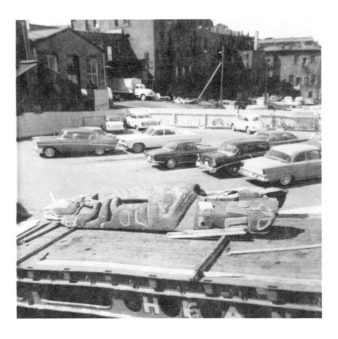

POLE 20B

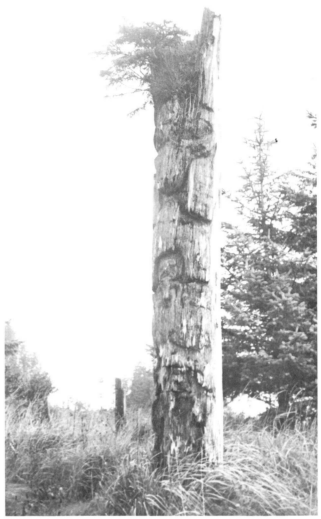

20B

The close relationship between the five families in Skedans is borne out, not only by the repetition of certain crests, but also by the number of poles bearing almost identical combinations of crests. This pole, for example, is a near twin to a mortuary 6b (page 50) at the other bend of the village. The grizzly bears on the box-fronts are quite similar except that in this instance, the surrounding painting had weathered away when the photo was taken.

The top figure on the support column is once again the killer-whale crest of the Raven clans, looking more like an ordinary whale. The blow-hole appears on his forehead with the upside-down human face peering out from within. The pectoral fins are folded forward, the flukes hang straight down, unlike the whales on the house frontal poles which seem always to have their tails turned up in front.

Protected by the arc of the whale's tail is a small human figure, and he in turn, squats on the head of the bottom figure. On the previous pole, the bottom figure was a bear, but here it is a sea-bear holding his segmented snag of wood, the Tca-maos crest figure. The segmented snag seems to double in use as a property-hat for the spirit figure at the very bottom.

This mortuary is still standing at the site, the box front gone as always, and, as always, the view to the sea blocked by trees.

20c GRIZZLY BEAR MORTUARY BOARD

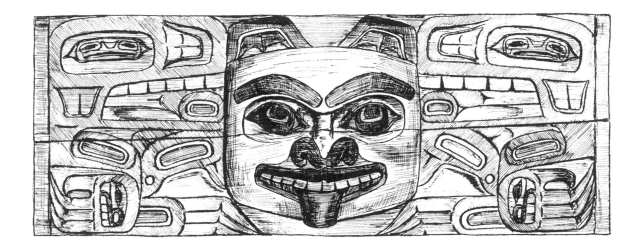

20C

There must have been several grave-houses in Skedans similar to that at the western end upon which the eagle perched, but most of them were hidden from view in the photographs. One is mentioned in Dr. Newcombe's notes[44] as being behind "Grizzly Bear House," and it attracted his attention only because it contained the large mortuary box front illustrated here. He sketched the elaborate painted design containing the formalized elements of the bear's body, and added the comment that the bear's head in the center was "like the one at Chicago," referring to the almost identical mortuary frontal which he sent to the Chicago Field Museum (page 50).

Apparently, Dr. Newcombe did not remove this board, but someone else did. A photo of it is pre-served in the Provincial Museum, Victoria, and on the back is written, "Stolen mortuary crest ex Skedans, Q.C.I. Photo taken at Alert Bay by C.F.N. June 1905 now at Field Museum." This cryptic notation would seem to indicate that Dr. Newcombe saw the board at Alert Bay, recognized it, photographed it, and eventually secured it for the Field Museum. If so, the Field Museum must have two nearly identical boards, possibly from the same carver.

WING DESIGN

101

21 TWO BEAM HOUSE

The last house in the long row of houses along the back of the bay was a two-beam house having no house frontal pole. Chief Skedans could remember no house name but listed it as belonging to the "Peninsula-People" of the Raven clan.

The house appeared at the extreme right hand edge of Dawson's last photo of the village and was immediately noticeable. Unlike the six-beam houses whose huge chamfered roof timbers projected three or four feet over the front gable, the two-beam house gable presented a smooth unbroken face (see page 87). The two front support posts (matched by two at the rear of the house) were hidden behind the frontal boards. These upright supporters had a saddle cut out at the top to cradle the two longitudinal roof timbers (whose ends were hidden by gable plates, but whose position is shown below by circular dotted lines).

Cross members were used to tie the structure together, and a smoke-hole was left in the center of the roof as with the six-beam houses, with a hatch to keep out the wet. The walls were sheathed with cedar planks and the roof with cedar shakes held down by fair-sized boulders, but in all, much less wood was used in the construction.

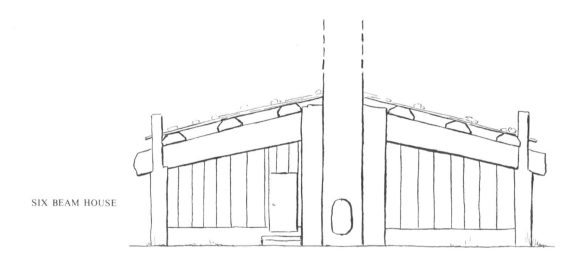

SIX BEAM HOUSE

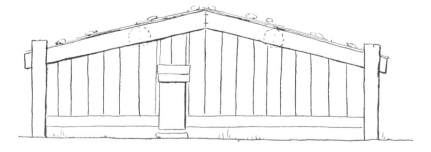

TWO BEAM HOUSE

21a EAGLE MORTUARY

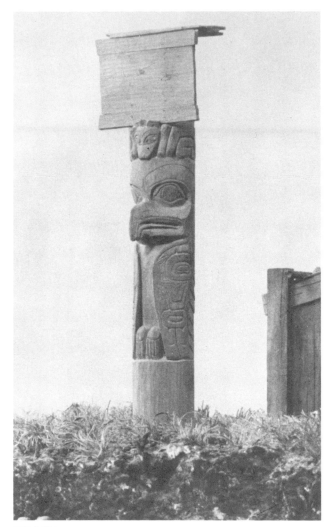

POLE 21A

The size of this mortuary probably accounted for the fact that it was one of the first complete poles to be taken away from Skedans. About fifteen feet high, it was not much larger than the inside houseposts which were also a target for early collectors. In this instance, the Field Museum in Chicago was once again the recipient, as the result of Dr. Newcombe's efforts on their behalf.

The mortuary box, shown here unadorned, probably had a painted design at one time. It may be interesting to note that as a painted board was exposed to the elements, the unpainted portion began to decay much sooner than the painted. After several years, the painted surfaces would stand up a fraction of an inch from the surrounding unprotected board, giving the impression of a low relief carving where none had originally existed. This is not always noticeable in photographs to any great extent unless the light is just right, but a close personal examination of a board from which all traces of paint have finally disappeared can sometimes reveal the faint outlines of the design still "etched" into the weathered surface.

The eagle, a fine strong carving of the clan crest, stands alone on this pole, except for the bear cub crouched between his ears. Apparently the eagle crest originated from the capes of eagle skins worn by the West Coast people. This idea is interwoven into the legends where human beings were able to don capes of eagle skins and fly out to sea to hunt for whales.

The eagle was also associated with the Raven in the long series of Raven stories but we have not been able to find any specific connection with a bear cub, so the presence of this little animal may be intended to record a marriage connection.

OTTER DESIGN FISH FLOAT

103

21b PLAIN MORTUARY

Plain mortuaries appear in photographs of other Haida villages, but this is the only one in Skedans. One might assume that these were "economy" models, raised by families not really wealthy, who nevertheless were struggling for social status and a higher position, but this assumption has no foundation. There is no reason to suppose that a section or two of carving would have been vastly expensive.

In any event, the box front was almost certainly painted to begin with, for there would have been no purpose in erecting a memorial to honour someone without recording their identity by way of their family crests. There was no suggestion that the pole was intended to be carved at a later date. The upper half of a mortuary support post could be fluted as a means of decoration, or carved, but all work was done before the pole was ever erected.

The poles may, of course, be a throw-back to an earlier time when grave-boxes were simply fastened to the tops of plain posts to get them up off the ground. Early mortuaries may all have been much simpler before the introduction of metal tools and commercial paints, and conservative minded families may have preferred the old style. If special circumstances were involved in the erection of these plain posts, however, we would very much like to know what they were.

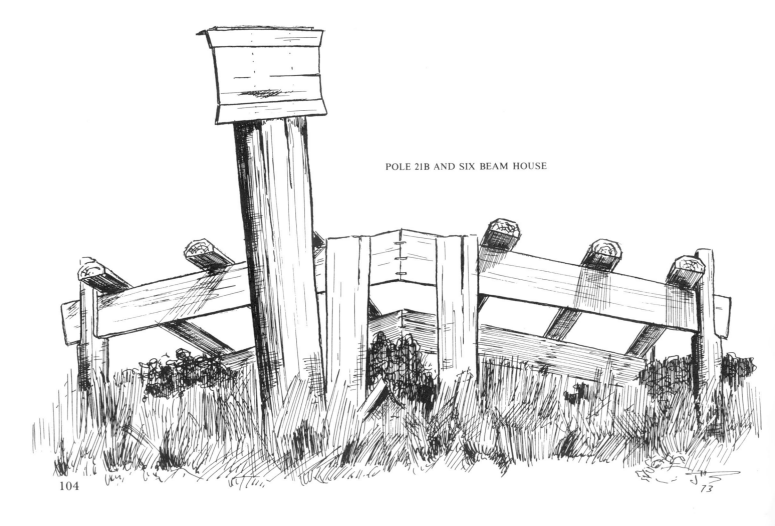

POLE 21B AND SIX BEAM HOUSE

22 HOUSE TWENTY-TWO (MISSING)

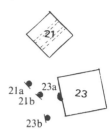

At this point in the village, Dawson's photographs indicate the houses took an almost right-angled turn and continued south onto the peninsula in a straight line, each house front stepped back slightly from the last. He photographed them end-on, and the last of the row was derelict, but with a house frontal pole still in place. Four house frontals can be counted, but a later photo indicated that there was a two-beam house tucked back in the corner, making five houses in the last leg of the village.

Unfortunately, Chief Skedans' list indicates there should have been six houses remaining. At which end of the row the sixth house should have been remains a matter of speculation, if indeed, the chief's memory did not play him false. Presuming him to be correct, however, and seeing no evidence of a house ever having been at the extreme outer end of the row, we have assumed that the missing house must have existed somewhere in the turn of the village. It was either gone by Dawson's time, or was hidden by a curious coincidence of photograph angles. The eastern corner of the village is just out of every known picture of Skedans.

SKEDANS 1897 NEWCOMBE

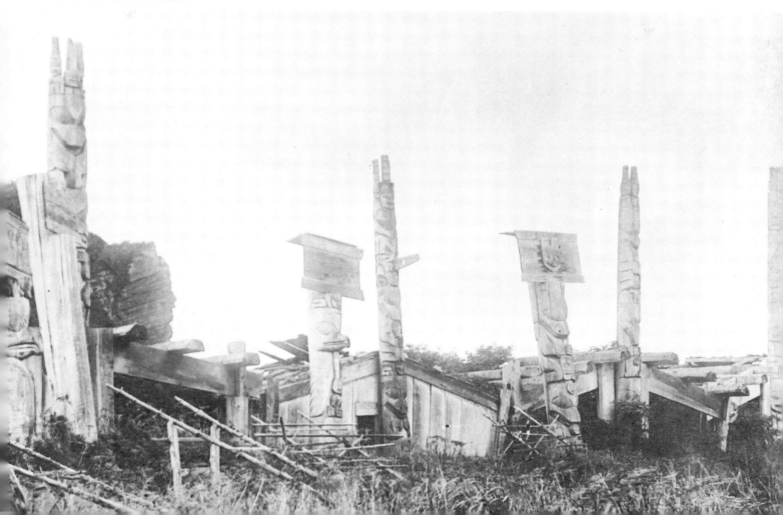

23 WASTE FOOD HOUSE

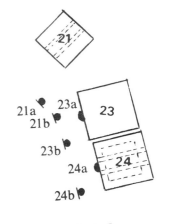

POLE 23A

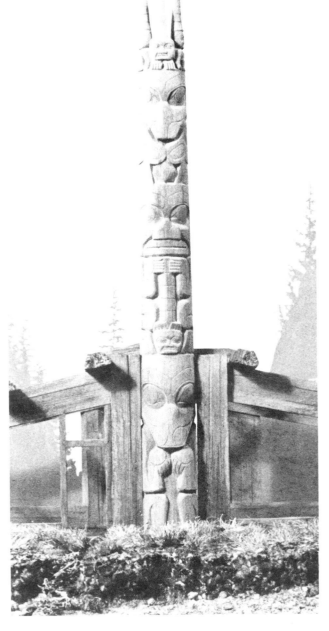

We are told that the twenty-third house was called "Waste-Food House" (waste food was bones, also undigested food found in fishes, etc.). Swanton adds that it was first the name of a salmon-trap, which the owner subsequently bestowed upon his house.[45] In this connection, the name must be an oblique reference to the practise of throwing the entrails of the gutted fish back into the water in order to ensure a good salmon run on the following year.

The house stood at the bend of the village. It too was a Raven house, of the "Peninsula-People", and carried one Eagle and two Raven crests. The top figure, the whale, is an Eagle crest, and appears here with its tail turned up in front of its body in the usual fashion for house frontals. Its dorsal fin appears over its head between the two watchmen, and a very round little face intercedes; either the 'face in the blow-hole', right-side up for a change, or the third watchman, or the joint between the fin and the body decorated with a face in the characteristic Haida fashion.

The second figure, for which we have no contemporary identification, we have been calling the Tca-maos, or Snag-of-the-Sand-Bar, the sea-grizzly with the wooden snag on its back. On poles at Tanu, the identical figure is shown but with the segmented column rising out of the head. At Skedans it seems always to appear as a tail turned up in front of the body, sometimes with a face at the base of the tail, as it was said to appear in a version of the Tca-maos legend. It is a Raven crest.

The bottom figure on the pole is also a Raven crest, the grizzly bear. The bear's nostrils are not so pronounced as is customary, but the paws held up to the chest and the wide upturned mouth make the identity obvious.

This pole has disappeared from the site.

23b EAGLE MORTUARY

This eagle mortuary is still standing at Skedans. The boards of the mortuary box, which showed traces of paint in the 1878 photographs have dropped off and disappeared, but the post remains standing, leaning backwards a little.

The human face over the eagle's head has been obliterated completely by the thatch of seedling trees growing in the mortuary cavity, though knees can still be seen in the eagle's ear spaces. A great gap has opened down the middle of the bird's face, the beak has gone, and almost no trace appears of the property-hat and human figure in front of the eagle. All is rotted away, and the rot has continued back into the pole, leaving the wings, almost perfectly preserved on the surface as a protective shell around a decaying core.

It would be a delicate and expensive task to try to check the decay and strengthen the pole in order to lengthen the life of the portions that remain.

POLE 23B 24B DUFF 1953

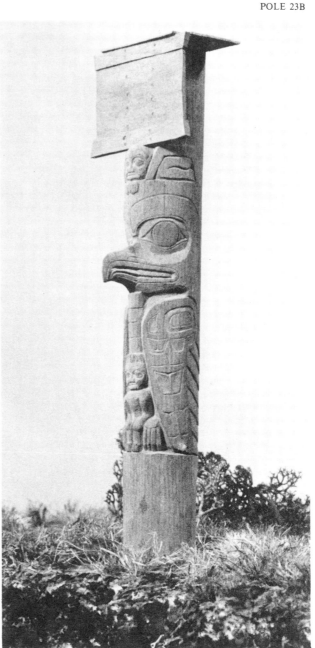

POLE 23B

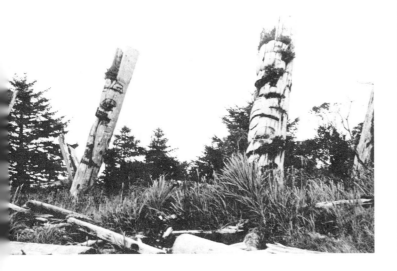

24 ALDER HOUSE

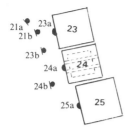

24a HOUSE FRONTAL

"Alder House" was a two-beam house, the second house in the row of five on the eastern shore of the bay, all of which belonged to the "Peninsula-People" of the Raven clan. There is no indication that this house frontal was standing at the time of Dawson's visit, for although the fronts of the houses cannot be clearly seen in his photo, the poles were visible in profile, and this pole, with its projecting fin, should have been visible had it been there. It may possibly have been the pole lying on the beach in front of "House With Two House Posts" but erected at a later date and appearing in Emily Carr's and C.F. Newcombe's photos after the turn of the century. Newcombe described it as a "painted pole" indicating that it must have been fairly new for the paint not to have worn away.

The bottom figure on the pole, with upraised paws and slightly protruding tongue is a straightforward representation of the grizzly bear, with the head of a bear cub between its ears. The cub's forepaws appear in the ear spaces of the parent figure.

The rest of the pole is taken up with the combination figure of the sea-grizzly bear. From the bear's head in the center, a bear's body, arms and legs appear below. The killer-whale's fins, body and tail appear above. The killer-whale portion of the sea-grizzly's nature is reinforced by the projecting perforated dorsal, and by the appearance of the small sea-creature in the sea-grizzly's mouth.

The two human figures holding and riding the tail of the sea-grizzly are the usual figures associated with the killer-whale. These are often said to represent Gunarh, the legendary hero who

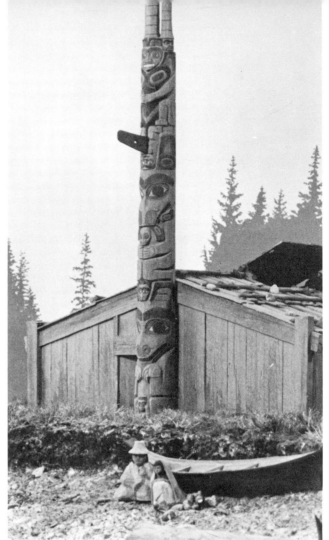

POLE 24A

travelled beneath the sea to rescue his wife from the killer-whales. Sometimes they have been called space fillers. But we are more taken with the legend of the two brothers, one of whom was turned into a killer-whale, the other who went out with him to hunt at sea, when explaining these two figures. Without supporting evidence in the form of contemporary record, however, we must admit to the Scots verdict of "Not Proved."

The head and property-hat of the "spirit" figure, however, acts as the central watchman of the usual three. The other two are almost hidden behind the whale's flukes.

The pole was removed from Skedans to Prince Rupert in 1935 where it joined two others from Skedans. Encroaching decay caused it to be removed to Victoria in 1968 where local Indian artists had made a replacement copy for the city of Prince Rupert. The original resides with the Provincial Museum.

24b BEARS AND KILLER-WHALE MORTUARY

This bears and killer-whale mortuary also remains at Skedans. Its mortuary box front, once carrying the head and claws of the grizzly bear crest of the Raven clans has gone. The lower part of the pole is badly decayed, soft and crumbling to the touch, and the whole leans backward at an alarming angle. It will not stand much longer.

The top figure on the support post is that of the bear, holding upside down the body of a "spirit" figure, whose arms clutch the bear's paws. The suggestion is that the bear is eating the man, and this ferocious aspect, combined with the killer-whale beneath, might mean that the two figures should be linked into the sea-grizzly crest figure. A second explanation might be that the owner of the grizzly-bear crest at some point in his career won a dispute with a shaman, or otherwise overcame some supernatural creature, with the aid of his totem guardian. Other explanations are possible.

The bottom figure is that of a whale, and must be the killer-whale to conform to the other Raven crests on the pole. Its pectoral fins turn

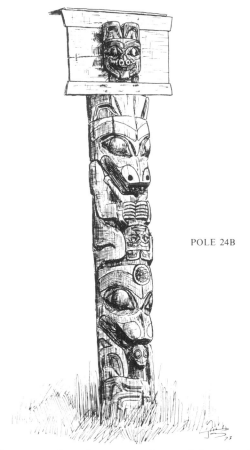

POLE 24B

downward and are overlapped by the flukes of the tail turned up in front. The whale holds the head of a smaller sea-creature in its mouth as the only indication that the scana, or killer-whale, was intended. There is no sign of a perforated dorsal fin, the usual signature of the killer-whale.

POLE 24B DUFF 1953

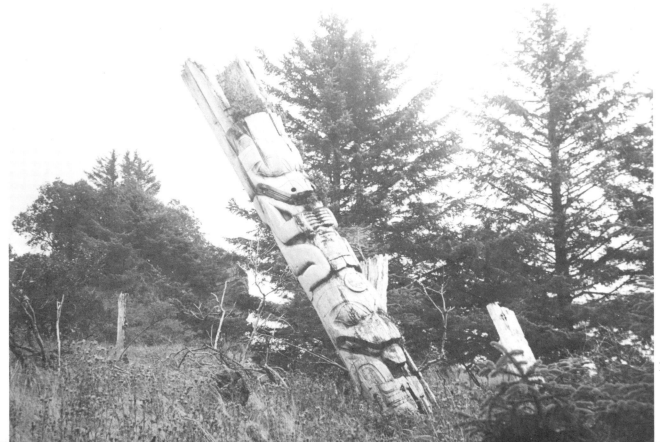

25 HOUSE TWENTY-FIVE

25a HOUSE FRONTAL

The last three houses at the east end of Skedans had no names on Chief Skedans' list. All three houses were six-beam dwellings, and all were probably unoccupied when Dawson photographed them in 1878. They showed signs of deterioration even then, particularly the last which was most exposed. By 1927 not a single house frame remained standing on the peninsula.

The poles, however, survived fairly well, disappearing one by one over the years. This house frontal for example, vanished sometime between Newcombe's 1901 photo, and Emily Carr's 1912 photo, and it is quite possible that its disappearance might have had some assistance by collectors.

The top figure is unmistakeably a bear, with paws held up and tongue protruding. At his feet squats a little "spirit" figure, his legs drawn up in front, his arms bent backward in a most uncomfortable position, allowing the backs of his hands to appear in the upper corner of the ear spaces of the bear below.

The figure below is the only vertical crest figure in Skedans that carries a close resemblance to a wolf, with a mouth full of teeth and a long snout without the rounded nostrils so characteristic of the bear. A human figure is held upside down in the creature's mouth, and while this is often typical of bear crests, it could conceivably be associated with a wolf as well. The absence of any sign of a wolf's bushy tail leads us to conclude, rather reluctantly, that this figure too, is probably a grizzly bear.

The bottom figure is that of a human being with hands upraised. A very small doorhole was cut through the body. The long tag hanging from

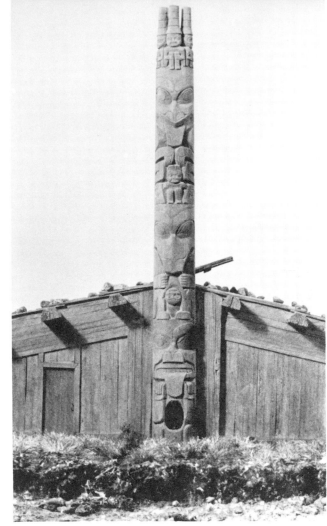

POLE 25A

the lower lip resembles a tongue, but is more likely an enlarged lip plug indicating a woman of very high social rank, either an ancestress of the clan, the wife of the owner of the pole, or perhaps a chieftainess who raised the pole, as sometimes happened.

The combination of two bears and a woman strongly suggests the berry-picker of the Bear Mother legend. The woman of high rank at the base of the pole may be the "princess", or young woman of the story whose capture by the grizzly bear may be depicted in the central group. She later took on the characteristics of a bear herself, and the bear at the top with the accompanying "spirit" figure may be intended to signify her half-human, half-bear, supernaturally changeable nature.

This is only conjecture, however, and a person familiar with the carver's intention, or present at the original raising ceremony, might have had quite a different story to tell.

SKEDANS VILLAGE FROM SOUTH

DUFF 1954

SKEDANS PHOTOGRAPHED FROM HILL BEHIND VILLAGE

DUFF 1953

26 HOUSE TWENTY-SIX

26a HOUSE FRONTAL

This house frontal pole now forms part of the collection of the Lowie Museum of Anthropology at the University of California. According to information kindly provided by the Museum staff, the pole was obtained by Dr. Newcombe from Skedans in 1910, purchased from a man named Haostis who had erected the pole about 1870. The Lowie Museum acquired the pole from Dr. Newcombe in 1911 but the brief notes he provided as to its meaning cast only a little light on the identification of the main figures.

The top figure on the pole, beneath the watchmen, is a bird whose snubbed beak suggests the hawk. Dr. Newcombe, however, identified it as being a "toothed eagle" and the crest of Haostis' wife, K'awa, who was a member of the Eagle clan. The eagle is linked with a spirit figure which emerges between the bird's curled talons, and as stated previously, we believe these spirit figures to indicate the supernatural spirit nature of the major crest figure.

The next crest figure is that of a human being, with a small bird emerging from its mouth. Unfortunately, Dr. Newcombe neglected to describe this figure, merely mentioning that the frog on its chest was another of K'awa's crests. We tend to think that this grouping is a composite of the wife's geneology — the eagle having been represented once in its bird form at the top of the pole, it is now repeated in human form with the small eagle emerging from within to demonstrate its true nature. The frog designated the sub-division of the Eagle phratry to which the wife belonged.

Marius Barbeau[46] describes this figure as

> . . . perhaps the Raven in human form with the Eagle or perhaps Butterfly in his mouth, and the frog on his body.

The third figure, with its animal ears, wide mouth and circular nostrils resembles a bear, but in a humanized form with hands and arms rather than forepaws. In front sits a small semi-human figure with the odd flippered hands also to be seen on the Rainbow spirit (Poles 6a and 8a). Of this group Dr. Newcombe said only that it represented a "mountain spirit demon" and was merely "ornamental filling."[47] This has been taken to mean that the large figure was "ornamental" but Dr. Newcombe usually referred to only the small figures as being "ornamental." We suggest that it was the small figure that was the mountain-demon, over whom Haostis won some kind of victory, as it is being dominated by what appears to be Haostis' crest figure, the grizzly bear, in a humanized form.

The bottom figure is the grizzly bear, the main crest figure of this Raven chief. Between his feet crouches a small chief, probably Haostis himself.

POLE 26A

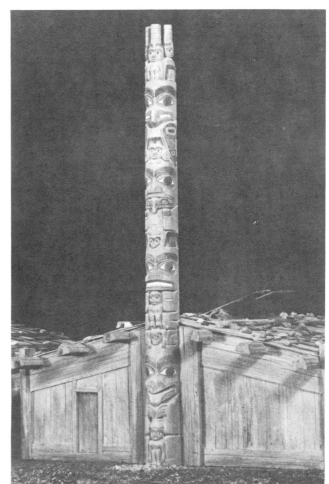

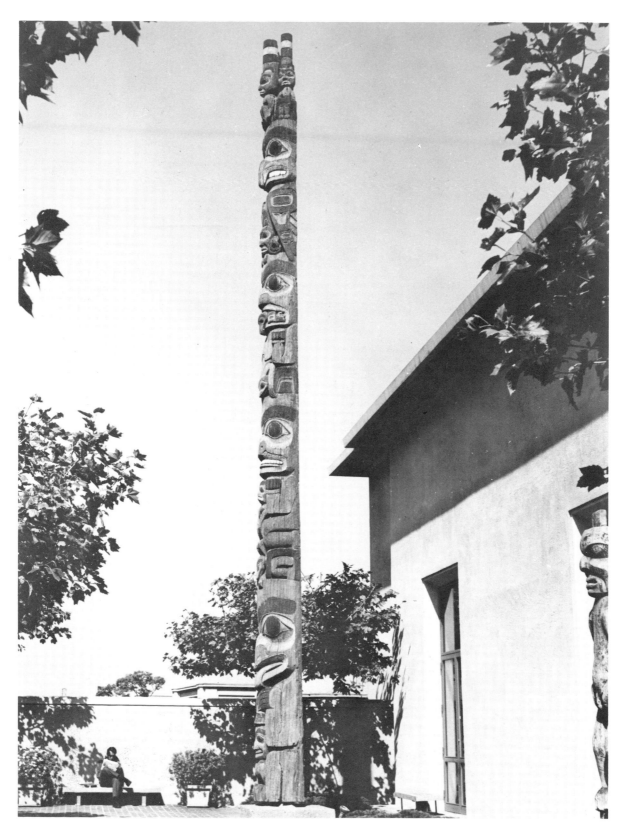

POLE 26A AT ITS NEW RESTING PLACE AT UNIVERSITY OF CALIFORNIA, BERKELEY

27 HOUSE TWENTY-SEVEN

27a HOUSE FRONTAL

The last house frontal stood at the eastern end of Skedans, well out on the peninsula that gave the Raven family of Skedans the name of the "Peninsula-People." The pole stood for almost 100 years until it was removed by the University of British Columbia-Provincial Museum team in 1954.

The top figure, that of a bird with a blunted beak and half-moon eyes, is the hawk, but its linkage here with a whale held in its beak, indicates that it is really the Haida version of the mythical thunderbird. The accompanying legend, as given by James Deans,[48] was that the scamsun, or mosquito hawk was an enormous bird which lived in the mountains from which it flew over the sea in search of whales. The clapping of its wings caused the thunder, and the flashing of its eyes, the lightning. Other versions[49] state that the thunderbird was in reality a man with supernatural powers who put on a coat of feathers, and equipped with talons, went out in search of whales as food. The "spirit" head below the whale's mouth in this grouping may indicate the dual identity of the thunderbird.

The central figure on the pole is similar to that which we have been calling the Tca-maos, but here the tail or driftwood stick has also become the property-hat of the human figure sitting between his feet. If not the Tca-maos, a mythical land animal of some kind was certainly intended; possibly the grizzly bear in human form corresponding to the conventional crest figure of the grizzly at the bottom of the pole. The figure in the property-hat would then likely be the owner of the pole.

114

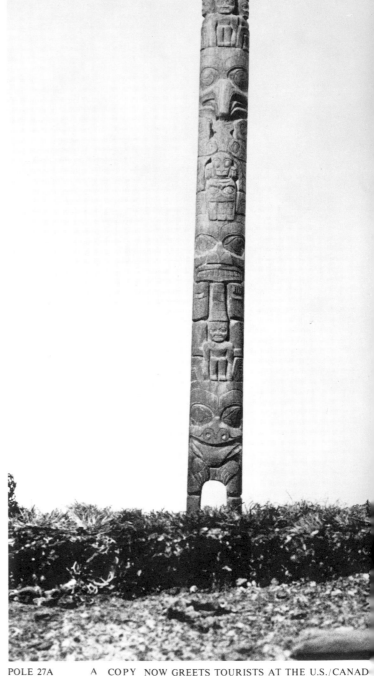

POLE 27A A COPY NOW GREETS TOURISTS AT THE U.S./CANAD BORDER CROSSING AT BLAINE

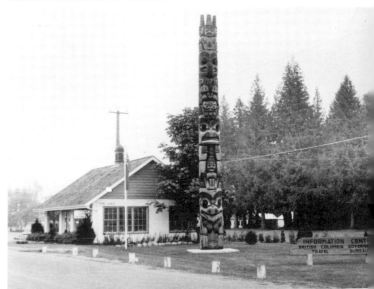

27b BEAVER HORIZONTAL MEMORIAL

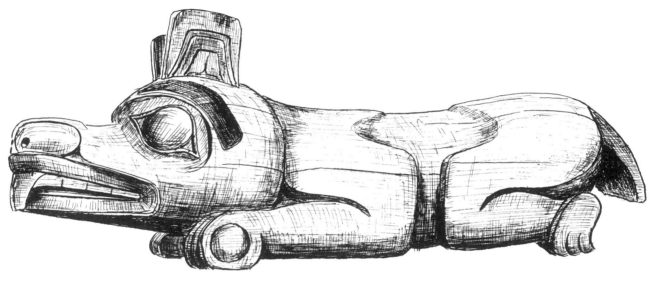

POLE 27B

At the top of the slope from the beach, surrounded by the salal and weeds of a village already showing neglect in 1878, the beaver horizontal memorial rested, looking out to sea. His friendly, dog-like expression, and his broad smooth back invited the passer-by to climb up and sit. In Dawson's photo, a man in a black hat and coat has taken advantage of this ready-made seat in the sunshine, and sits comfortably, seemingly half-asleep, his indifferent back turned to the camera.

In other places as well, horizontal memorials give witness to an everyday use not originally intended. In Kispiox, on the Skeena River, a bear horizontal is a play place for the village children who climb and clamber over him. In Victoria's Thunderbird Park, countless hundreds of tourists have been photographed upon the back of the whale horizontal memorial there.

Not much remains of the beaver memorial at Skedans. The forest has grown in around it. A sodden, crumbling lump, no longer in the sunshine, it too has passed out of usefulness.

The eagle memorial at the western end of the village was sentry and symbol. The beaver at the eastern end was symbol and friend. Both were born at Koona. One gone, the other rotten; all that is left of Koona lies between.

EPILOGUE

June 19, 1957. Sunny. 3:45 p.m. Skedans

The seiner crept into the bay, nosing its way through the kelp beds that strangled the passage. We had a Haida crew, who, like their ancestors, knew every hazard and every harbour of these Islands. The rhythmic pulse of the engine stopped. We could hear the ripples made by the seiner as they lapped upon the beach. Silence.

The waters of the small bay sparkled and glittered in the sunlight. On three nearly straight sides the rocky beach held us enclosed. Above the beach grew the forest, green and vigorous. To the left, lay the bulk of Louise Island; to the right, the rocky outcropping of the peninsula. In front, over the back of the bay, the land strip was narrow and we could see the top of an island that lay in the next bay to the north.

Our eyes were not focussed upon the natural beauty however, but upon the weatherbeaten broken line of totem poles slanting left and right among the trees. No more than a dozen in all, they were all that remained of Those Born at Koona.

The skiff was lowered into the water and we rowed ashore.

We walked through the town from west to east. The coarse sea-grass grew tall. Young trees pushed up everywhere. The big-houses lay in ruins, covered in club moss and seedlings. Poles lay face downwards, their carvings pushed deep into the damp ground. Others, still standing, wore a thatch of scrub brush bristling from their tops, sprouting like hair from every pit and crevice.

We quickly noted which poles remained standing, which had recently fallen, which had disappeared without a trace. With no time to survey the site correctly and fix the position of the remaining poles, we took a few measurements and photographs.

Then the seiner's horn sounded, loud and clear. The echo bounced back from the hill.

We left Skedans to the silence.

September 11, 1971. Sunny. 4:45 p.m.

The pilot of the Grumman Goose agreed to take a swing over Skedans to check on the site. The plane banked sharply and the island lay spread below us. Several oil drums had been stored on the beach in front of the village. On the north beach, several mobile bunk houses of the lumber company lined the shore. A new roadway led up over the hill to the main part of Louise Island and we could see a road grader working on the slope of the hill.

The plane banked again. The few totem poles on the south beach stuck up bleached and barren from among the living trees, looking like nothing more than dead snags from the air. But they were still there, and still standing.

We turned again and headed towards Sandspit.

KOONA RESTS IN SILENCE

FOOTNOTES

[1]J.R. Swanton, *Contributions to the Ethnology of the Haida,* American Museum of Natural History, Jesup North Pacific Expedition, 1905, p.12.

[2]John Work, cited in G.M. Dawson, *Report on the Queen Charlotte Islands, 1878,* Geological Survey of Canada, Dawson Brothers, Montreal, 1880, p.173.

[3]Swanton, *op.cit.,* p.284.

[4]Swanton, *ibid.,* p.79.

[5]Swanton, *ibid.,* p.284.

[6]Reproduced here with the kind permission of the National Archives of Canada and the Geological Survey of Canada.

[7]Dawson, *op.cit.,* p.169.

[8]Emily Carr, *Klee Wyck,* Clarke, Irwin & Co. Ltd., Toronto, 1950, p.29.

[9]Swanton, *op.cit.,* p.273.

[10]Swanton, *ibid.,* p.284. All subsequent references in this volume to house names come from the same source.

[11]Swanton, *ibid.,* p.124.

[12]Swanton, *ibid.,* p.130.

[13]Dawson, *op.cit.,* p.152.

[14]Marius Barbeau, *Haida Myths Illustrated in Argillite Carvings,* National Museum of Canada, Bulletin No. 127, 1953, p.139. Reproduced with permission of Information Canada.

[15]Viola E. Garfield and Linn A. Forrest, *The Wolf and The Raven,* University of Washington Press, Seattle, 1948, p.33.

[16]Swanton, *op.cit.,* p.284.

[17]Swanton, *ibid.,* p.123.

[18]Swanton, *ibid.,* Plate II, Figure 1, p.124.

[19]Swanton, *ibid.,* p.109.

[20]Swanton, *ibid.,* p.27.

[21]James Deans, *Tales from the Totems of the Hidery,* Archives of the International Folk-Lore Association, Chicago, 1899, Vol. II, pp.35-37.

[22]Dr. C.F. Newcombe, Manuscript Notebook, 1897, Provincial Archives, Victoria, B.C.

[24]Swanton, *op.cit.,* p.125.

[25]Deans, *op.cit.,* p.56.

[26]A complete list of Raven and Eagle crests on page 24 is drawn from J.R. Swanton.

[27]Swanton, *op.cit.,* p.124.

[28]Swanton, *ibid.,* p.131.

[29]Dr. C.F. Newcombe, cited in Marius Barbeau, *Totem Poles,* Vol. I, National Museum of Canada, Ottawa, 1929, p.122.

[30]Dawson, *op.cit.,* p.153.

[31]Newcombe, Manuscript notebook, 1897.

[32]Swanton, *op.cit.,* p.131.

[33]Marius Barbeau, *Totem Poles of the Gitkasn, Upper Skeena River, British Columbia,* National Museum of Canada, Ottawa, 1920, p.106. Reproduced with permission of Information Canada.

[34]Barbeau, *Gitkasn,* p.93.

[35]Swanton, *op.cit.,* p.284.

[36]Swanton, *ibid.,* p.128.

[37]Swanton, *ibid.,* p.111.

[38]Swanton, *ibid.,* pp.231-2.

[39]John Bartlett, "A Narrative of Events in the Life of John Bartlett of Boston, Massachusetts, in the years 1790-1793, during Voyages to Canton and the North-West Coast of North America," cited in Marius Barbeau, *Totem Poles,* Vol. II, p.803. Reproduced with permission of Information Canada.

[40]Capt. George Vancouver, "A Voyage of Discovery to the North Pacific Ocean, etc.," 1798, cited in Marius Barbeau, *Totem Poles,* Vol. II, p.806. Reproduced with permission of Information Canada.

[41]Barbeau, *Totem Poles,* Vol. I, p.314. Reproduced with permission of Information Canada.

[42]Barbeau, *Totem Poles,* Vol. I, p.122. Reproduced with permission of Information Canada.

[43]*Loc.cit.*

[44]Newcombe, Manuscript notebook, 1897.

[45]Swanton, *op.cit.,* p.285.

[46]Barbeau, *Totem Poles,* Vol. I, p.223. Reproduced with permission of Information Canada.

[47]Dr. C.F. Newcombe's notes, as recorded on the museum catalogue card 2-10723, and kindly provided by the Robert H. Lowies Museum of Anthropology, University of California, Berkeley, California, in correspondence with the authors, 1971.

[48]Deans, *op.cit.,* p.94.

[49]Barbeau, *Totem Poles,* Vol. I, pp.146-50. Reproduced with permission of Information Canada.

REFERENCES

Artifacts of the Northwest Coast Indians, by Hilary Stewart, Hancock House Publishers, Saanichton, 1973.

Art of the Northwest Coast Indians, by R.B. Inverarity, University of California Press, Berkeley, 1950.

Arts of the Raven, by Wilson Duff, Bill Holm, and Bill Reid, Catalogue, Vancouver Art Gallery, 1967.

British Columbia Heritage Series: Our Native Peoples, British Columbia Department of Education, Victoria, B.C. Vol. 1. Introduction to Our Native Peoples. Vol. 4. Haida.

Contributions to the Ethnology of the Haida by J.R. Swanton, Jesup North Pacific Expedition, American Museum of Natural History, Vol. 5, 1905.

The Haidah Indians of Queen Charlotte's Islands, by James G. Swan, Smithsonian Contributions to Knowledge, Vol. 21, 1874.

Haida Myths Illustrated in Argillite Carvings, by Marius Barbeau, National Museum of Canada, 1953.

Monuments in Cedar, by Edward L. Keithahn, Superior Publishing Co., Seattle, Washington, 1963.

Northwest Coast Indian Art, by Bill Holm, University of Washington Press, Seattle, 1965.

Primitive Art, by Franz Boas, Dover Publications, New York, 1955.

Report on the Queen Charlotte Islands, by George M. Dawson, Geological Survey of Canada, Montreal, 1880.

Thunderbird Park, by Wilson Duff, Department of Travel Industry, Queen's Printer, Victoria.

Totem Poles, by Marius Barbeau, Volumes I and II, National Museum of Canada, Bulletin 119, Ottawa, 1950.

Totem Poles of the Gitksan, Upper Skeena River, by Marius Barbeau, National Museum of Canada, Ottawa, 1929.

Tsimshian Myths, by Marius Barbeau, National Museum of Canada, Ottawa, 1961.

The Wolf and the Raven, by Viola E. Garfield and Linn A. Forrest, University of Washington Press, Seattle, 1948.

INDEX

BOLD FACE TYPE INDICATES PAGE NUMBER OF ILLUSTRATION

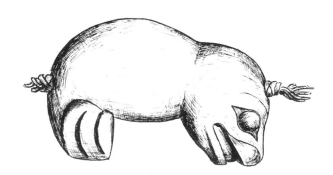